Developing the Creative Edge in Photography

Photo by George Patterson

Bert Eifer

Developing the Creative Edge in Photography

Writer's Digest Books

Cincinnati, Ohio

The photographs by R. Hamilton Smith, on pages 54, 90, and 115, are reprinted by permission of Graphic Art Center Publishing, Portland, Oregon, from their 1984 book *Minnesota II.*

Excerpt from *Photographic Seeing* by Andreas Feininger used by permission. Copyright 1973 by Andreas Feininger. Used by permission of the author and Prentice-Hall, Inc.

Library of Congress Cataloging in Publication Data

Eifer, Bert, 1923—
 Developing the creative edge in photography.

 Bibliography: p.
 Includes index.
 1. Photography, Artistic. 2. Photography, Freelance. I. Title.
TR642.E35 1983 770 83-21627
ISBN 0-89879-110-3

Design by Noel Martin

To my family whose love and respect, each for the others, has made me feel successful and joyous.

Special dedication to Elan and Adam, whose generation must begin the process of creating one family of this world.

Contents

Acknowledgments

From the very beginning, Judy Pomerantz read and corrected every word I put on paper — contributing her good sense to help clarify my meaning and intent.

The staff at API — Marie Cochetti, Sharon Winner, Susan Keefe and Dixie Thompson — have my gratitude for keeping the organization running smoothly while freeing my time to concentrate on this book.

My dear wife Elaine encouraged me (as she has all these years) and put up with my writer's frustrations — real and imaginary.

Karen Geller Shinn, editor of *Petersen's PhotoGraphic Magazine,* saved my life twice. When the number of excellent photographs submitted for the book got beyond me, I relied on Karen's experience, wisdom, and impeccable judgment for help in making final selections.

Again, when photo captions had to be written, Karen did the groundwork and developed the theme for each caption.

I am also indebted to the photographers whose work appears in this book. Those with the most to offer were the easiest to deal with. All give me great pride of association. Not only are they fine talents, they are exemplary human beings.

Most of all, without the miracle-working clone editors at Writer's Digest Books — Carol Cartaino and Howard I. Wells III — this book would have no form or flair, just unfulfilled promise.

And finally, a word of thanks to the twenty thousand current API members and the many thousands who have gone before. They are a willing, absorbing, and challenging audience. I have always enjoyed their correspondence — complimentary and provocative — and every personal encounter I have had with them.

Preface

This book is dedicated to the "tween" photographers — those who are beyond the basics but not yet producing work of professional, award-winning caliber.

I know you well, having written 120 issues of *APIdea Newsletter* to date—more than twelve years for twenty-thousand members of Associated Photographers International. I've been where you are now, struggling to find those elusive gems of wisdom that will unleash all that latent creativity.

You are a "serious" amateur. You are enchanted with the creative process and are willing to work to increase your proficiency and enjoyment of this art form we both love.

You own a 35mm camera with a TTL (through-the-lens metering system), or perhaps a larger format such as the 2-1/4. Chances are you own at least one lens in addition to your normal lens. However, you surely have already learned that more equipment is not the answer to creating better images.

You are a person of one sex or the other, so I should tell you that linguistically I am ambisextrous. Since there is no pronoun in English to cover both male and female, instead of using "he/she," "him/her," etc., I have opted for "him," with no offense intended. I often say "God in Her infinite wisdom" and speak of "Father Nature," so you can see I harbor no sexist bias.

Here you are investing your time and money (hopefully much more time than money) in a book that promises you a brighter future in photography.

I am dedicated to making this come true for you, but we must work together. *We are equal partners in this venture.*

This Writer's Intent

It started with a sixty-nine-cent molded plastic Univex camera* in Cleveland, Ohio when I was a preteen.

I have been involved in photography with varying degrees of intensity ever since, taking and later making photographs and buying pictures worth thousands of dollars during my career in marketing and advertising.

My interest heightened in my adult years, when I realized I had little talent and less patience to be a fine artist with a brush and palette. I turned to photography as a shortcut to satisfying my deep-seated need to "create."

Then, even though I had attained some degree of success in the business world, I decided that more than anything I wanted to be a professional photographer — a late career change. "Professional photographer" — it had a nice ring, prestigious, romantic. And imagine, making money doing what you really love to do!

When I made my decision I bore down on perfecting my skills, taking every class available, every seminar, workshop, lecture. I read all the books and magazines and tried to recall what I should have learned when I worked with top pros in advertising.

Then I began to freelance at photography and to make money at it! But I was wise enough to know that it was not so much my photo skills (modest) that enabled me to make money, but *my marketing ability* gained through my many years in business.

It seemed to me that other photographers and hobbyists who

Anyone who has information about the Univex camera, a picture of it, or an actual camera, please contact me % Writer's Digest Books.

were interested in freelancing needed marketing know-how too. That's why I started Associated Photographers International. I made a good guess because API is now the largest association of photographers in the world.

My means of communicating what I know about marketing photography is a monthly newsletter. Over the years I have received many hundreds of letters from members who validate my guidance; *they are making money in photography!*

But I detected a missing link. Success depends on continually upgrading the quality of your photos. Originally I left that to the major monthly magazines with their two-hundred plus pages, color printing, and extensive staffs and resources. But I felt they were, to great extent, filling space, recycling the same material over and over, and when they did cover the real nitty-gritty of creativity, they obscured it in all those words and advertisements.

So I took upon myself the second objective of extracting the sense from the nonsense and publishing in digest form the ideas and techniques for creating better pictures.

I have published *APIdea Newsletter* eleven months a year since 1971. So, more than a photographer, I am a *writer* about photography...about making spare-time income and better pictures. If I have a writing skill, it is this: If I can learn to understand an aspect of photography, I can make it understandable to you. I try to cut through the gobbledegook and *reduce things to their barest, basic essentials* and put them in the fewest words possible.

More than a writer I am an *analyzer.* Over the years I have dedicated myself to learning what constitutes the *pro difference.* I have tried to put my finger on the attitude, technique — those and other mysterious factors that make so vast a difference — to discover why some photographers create masterpieces and others, run-of-the-mill pictures, with relatively the same equipment.

More than an analyzer I am a *researcher.* To further my quest for

that elusive difference I continually look at pictures, talk with pros, attend workshops and lectures, and read everything I can get my hands on about photography and other wide-ranging fields. I dig and dig to find ideas, techniques, and philosophies that help me understand the *Creative Edge in photography*, and how to simplify it so others can actually put it to use.

More than a researcher I am a *synthesizer*. I try to bring together knowledge from fields as diverse as art and psychology to help photographers acquire that pro difference...to help them make photographs that are *more understandable*, have *deeper meaning*, and afford the photographer *greater personal expression*.

More than a synthesizer I am a *motivator*. I believe with my rational mind, and with my heart and soul, that anyone who tries will expand his horizon, his personal vision, his skill — *to the fullest extent of his potential*.

I believe we all have a vast reserve of latent talent, real power, that can be harnessed to produce great work, and the *personal creative satisfaction* we all crave.

I know that over the years I have helped thousands of hobbyists and other serious photographers to extend themselves. That is *my* satisfaction.

This book does not attempt to give you all you want to know about every facet of photography. Many volumes are now in print on every specialized area of photography. I urge you to read those in your fields of interest.

What *The Creative Edge* does cover are what I consider the IMPERATIVES — those attitudes and philosophies, as well as techniques, that provide a *foundation* for creating remarkably better pictures, pictures that can provide you with spare-time income if you wish.

This book can be a jumping-off place for some, a refresher for others. For some, *The Creative Edge* will be an entirely new way to think about photography.

This book will require effort on your part. You cannot read it passively. It is intended to make you think and then do.

These are only words on paper. You must be the generator who turns them into action and results. You *can* create photographs that are as great as you are *willing* to make them.

Willing means you are willing to expend effort.

Others have done it. Now it's your turn.

Bert Eifer
Woodland Hills, California
September, 1983

How to Read this Book

Start reading this book with the attitude, "I will learn to create remarkably better pictures." First, skim through the book. Then read one chapter at a time and take time to reflect on it and ask yourself: "How does it apply to me?" "How do I expect to profit from what I just read?" "What can I do to profit from it?"

Read with paper and pencil in hand for action notes. (Successful people are note takers!) Jot down what you expect to learn, starting with the fundamentals so that one skill builds upon another.

Once your expectations (goals) are set, the doing comes easy. As Aristotle said, "What we have to learn to do, we learn by doing." (*See Section 7, Fulfill Your Great Expectations.*)

Gain the Creative Edge

On the cover of the October 1978 issue of *National Geographic* is a reasonably good self-portrait of a gorilla in the Stanford University lab. A self-portrait! By a gorilla!! Reasonably good!!!

Some 40 million other Americans can take "reasonably good" pictures too! Where does that leave us "serious" photographers? "Reasonably good" is not good enough; you must make photographs that communicate information or emotion...clearly, artistically, and with impact.

You are into photography for any number of reasons:

• You have a strong feeling of "family" and enjoy the rich reward of recording the image of people who touch your life.

• Memories are important to you — people and places — and you know that photography is the way to preserve memories with the most realism.

• You want to document the human condition around you.

• You are sensitive to the beauty of nature and the significance of man's handiwork, and you derive satisfaction in recording the emotional impact of these wonders on film.

• There is that deep need within you to create, to express artistically that which you see.

Chances are very good that you have not realized your goal.
 Why?

For one, camera advertisers imply that you will take professional photos such as those shown in their advertisements through the simple act of buying their cameras. ("Look, ma, I'm a pro!") It didn't prove to be true, did it?

Second, most of the courses you take, the books and magazines you read, instruct you on the *craft* of photography — how to control depth of field, films to select, use of filters, and so on. Great as far as they go. The trouble is, they don't go far enough.

Not by a long shot.

The craft of photography is only half the story, the *easy half* that anyone can learn (although not everyone does). That is not to say the craft of photography is unimportant. Quite the contrary. The only way you can record your ideas and feelings — the *art* of photography — is to understand and use all the techniques of the craft.

In this book you will learn how to master the fifteen creative controls of your camera. You will see the technical aspects of photography in a new light and find them easy to perfect.

The other half of the story, the far greater half, is the *art of photography* — seeing photographically, interpreting feelings photographically, previsualizing, and capturing your feelings on film. Classes, books, and magazines give you few or none of these elements, the elements that I call the "pro difference." *The Creative Edge* will fill that gap for you.

And if you choose, your newly found creative edge can enable you to earn income from photography in your spare time. Since 1971, with the inception of API, I have helped photographers — even those with modest talent — turn their skills into money. Thousands of photographers have proved my point and profited by the simple guides I have provided in the newsletter and a booklet, *Shoot for Money.*

Attitude. In order to learn to create remarkably better pictures, you must approach your subjects with the right attitude.

Attitude. It's more important than aptitude!

A positive, "can do" attitude is the key that unlocks your latent potential. It will help you to be all that you can be as a photographer. It is the motivation that will enable you to get on track, to discipline yourself to work toward your goals...the key that makes you a winner in any facet of your life.

That's what *The Creative Edge* is all about.

I have analyzed thousands of pictures to determine what factors make some succeed, others fail. I have read extensively and talked to many outstanding photographers to learn *the secrets the pros know that amateurs don't.*

Conclusions. I have come to several conclusions.

If there is a secret, it is *hard work*...study and practice.

You must have the good sense to quit kidding yourself that luck or hidden talent will prevail. Luck is something that happens *only when you're prepared for it.* Hidden talent, like gold, stays hidden for a lifetime *unless you dig for it.*

To be an artistic and/or commercial success, you must commit yourself to the discipline of hard work. One paradox about photography is that the harder you work, *the more satisfying it is!*

The one decisive pro difference is *the ability to see photographically.* You'll find this idea recurring time and time again in this book.

Successful photographers follow a *definite mental process* when making pictures. This mental step-one, step-two, step-three thought process works on a subconscious level and varies among photographers, but it has a common pattern that I have used as a format for this book.

The sweet rewards of making outstanding photographs and banking extra income should encourage you to commit yourself to

fulfilling your great expectations in photography.

Let this book be your guide. It can only be a guide. To gain the competitive edge you must actively participate in this exciting adventure in learning, by absorbing and doing.

Especially doing.

Great Expectations

Alexander Pope was so right when he said, "Blessed is he who expects nothing, for he shall never be disappointed." Most of us are so blessed, otherwise why aren't we more successful in big and little endeavors?

"I will" is one of our truly magic phrases. It ignites success. All human motivation stems from these words.

The lower order of motivation comes from others expecting a certain behavior of you (extrinsic motivation). It works. Your company expects a certain quota of performance. You do it. The child is expected to do his homework. He does it.

The higher order of motivation comes from within, *when you expect something of yourself.* This is as rare as success itself!

A key to achievement in any area is to cut out the words "I might" and replace them with *"I will."*

Art and Photography

If you can increase your understanding of art in all its forms, you will gain the Creative Edge — a better chance to make photographs that are considered art.

Photography wasn't always discussed as an "art form." Less than 100 years ago it was struggling to be recognized as art along with painting and sculpture. Today, however, museums collect and exhibit photos, and art collectors often pay enormous sums for photographs by pioneer and contemporary photographers.

Just as with other art forms, photographs as art can be judged by their conformity to *established art principles*.

What, then, is art?

Far be it from me to define something artists, historians, and philosophers have debated for centuries. But I can paraphrase a few notables.

The common understanding is that *art pleases the eye*. But that is only a starting point. The most widely accepted definition of art is "to bring order to the chaotic material of human experience." That is to say — art creates *harmony*.

John Canaday, for nearly twenty years art critic of the *New York Times*, says the function of art is to "clarify, intensify, or otherwise enlarge our experience of life."

A professor at UCLA defines great art as having three components: mystery, ambiguity, and contradiction — terms all subject to their own interpretation.

Freeman Patterson, author of several books and one of the most effective photographer-teachers, says, "A work of art possesses a quality of mystery, an ambience."

In judging the pictures in this book against these definitions, you should ask: Do all the pictures adhere to these standards? How do they succeed? How do they miss? Use these same standards to judge your best work.

Regardless of definitions, the fact is the more you cultivate your art sense (taste), the more you will appreciate and enjoy art. This sense will reflect upon the quality of pictures you make.

People often say, "I don't know much about art but I know what I like." What they really mean is, "I like what I know."

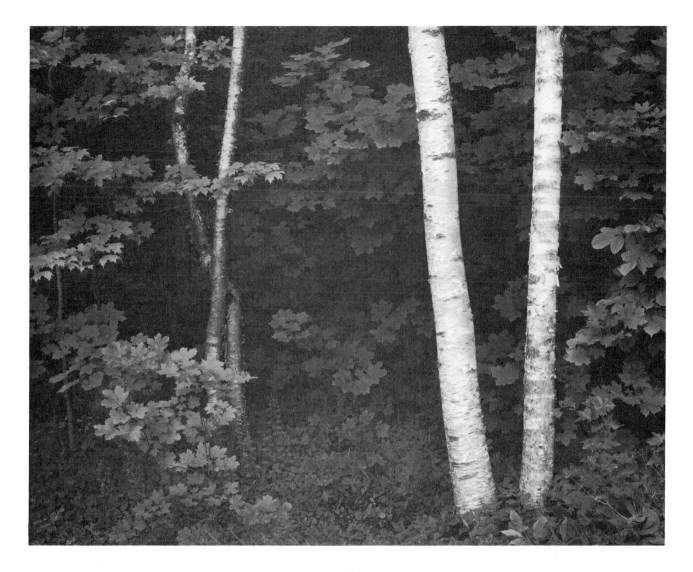

By selecting this simple scene and using his craft expertly, John Sexton allows us to experience the essence of "forest." Does this photo appeal to you as art? Are you aware of the harmony of the linear tree trunks and how pleasingly they blend with the careful rendering of the shadow area?

"Birch Trees, Rockport, Maine" by John Sexton

Broaden Your Art Knowledge. The idea is *to expand what you know about art.* The more you learn to appreciate, the more art principles you will incorporate into your pictures.

It is easier for many people to enjoy the work of Norman Rockwell than Picasso or Rembrandt or Monet. Understanding the masters requires effort, and Rockwell appears "easy to read." Our responses to his images are predictable, automatic, and comfortable. We need not tax our minds to look for hidden meanings or extensions of the obvious ideas presented.

Rich rewards come from the effort of learning to appreciate what we have to dig for. Look at it this way: Suppose you were cast away on a deserted island and could take only one book with you. Would you take a mystery novel from the supermarket? Or the Bible? Or a volume of Shakespeare?

You would consume the novel in a day or so. Either of the other two could entertain, teach, and challenge you for the rest of your days.

So it is with art in all forms, including music. The chic, the faddish are passing things. *Classics are forever,* even though they take your time and effort to understand and appreciate. The exciting thing is that with guidance you can learn to appreciate opera and Shakespeare and Mozart and Monet...and thereby *broaden your enjoyment of life!*

Deeper Meaning. Your appreciation of art ultimately determines the type and quality of the photographs you make. Will they be shallow and superficial like most you see, or will they possess *deeper meaning, a higher level of art?*

How do you broaden your understanding and enjoyment of art? *Expose yourself to art.* Visit museums, especially with a guide. Take art appreciation courses. Keep your eyes and your mind open while looking at — looking into — pictures.

Definition of Great

Time-Life selected 250 photos for the volume *Great Photographers* in the Life Library of Photography series. These photos represent the work of sixty-eight photographers selected from among thousands reviewed.

The editors based their definitions of "great" on a combination of factors.

Intent was the first criterion. What did the photographer have in mind, and did he achieve it? For instance, did the photographer succeed in making the viewer feel a sense of desolate waste when looking at his photo of a battlefield?

Next was *skill*. Did the photographer have mastery of the tools of his trade to execute his intentions?

Consistency followed. Did the photographer fulfill his intention time and time again? A single great picture — or even several — do not a great photographer make. He must produce a body of outstanding work, demonstrating that great photography is no happenstance, ruling out luck or accidents.

Measure yourself and your standards of greatness against *Life*'s.

Canadian college professor, photographer, and writer Denes Devenyi sums up: "A creative photographer would not only rely on the subject matter, he would add to it in some way by going beyond the specific subject to make a general statement . . . to make a photograph rich in psychological content . . . opening up the inner world of the image maker."

Set Standards

You will make good pictures only if your standards are high.

Every year hundreds of pictures are sent to me for the *APIdea Newsletter* or as submissions to our Compu/Pix/Rental stock photo agency. Over the years I have looked at many thousands of photographs.

Very few pictures are outstanding, most are fair, but some are so bad I am dumbfounded trying to understand *why photographers cannot see their own work for what it is!*

Can it be they have nothing with which to compare their work?

Have they never seen good photography?

Impossible. Every one of us sees millions of pro-quality images. They are pushed into our faces in books and magazines, billboards, brochures, newspapers — and television. It's said a child sees fifty thousand hours of television by the time he is a teenager!

Why then do photographers show pictures of people with green faces, subjects out of focus, scenics with nothing to see, pictures with no idea to convey, pictures with dust spots preserved as if they enhance the photo? And those are some of the good ones! Between these extreme examples and truly good pictures there is a gap a mile wide.

Part of the problem is that one of the most difficult feats for man is to objectively judge his own creations. Can you tell when your own work misses? Misses what?

Misses a *universal art standard.* If you have no standards by which to judge, you can only have misses. If you have something to compare with, and it is of high quality, then it must follow that you will learn from the comparison. Result: *more hits than misses.*

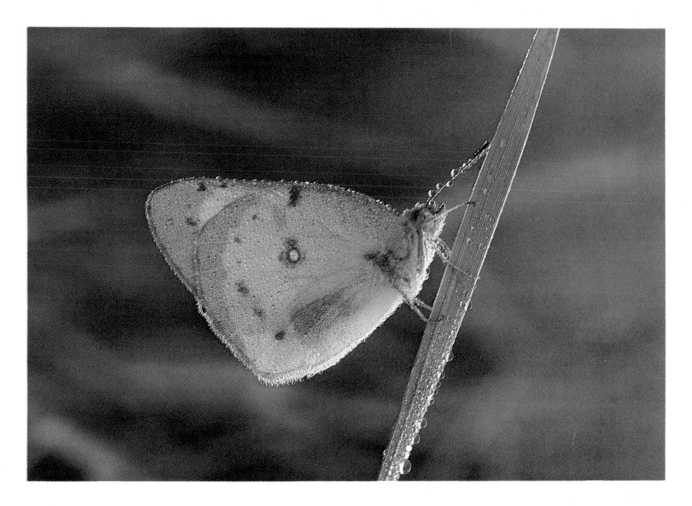

We can readily see this was no "lucky" shot. Jeff Marsh chose the right lens and positioned himself to take advantage of lighting that enhances rather than detracts, producing exciting detail where it's most important. Notice the simple, impactful design of the photograph. Photo by Jeff Marsh

Role Models. One solution is to set as your standard the work of one or several photographers whose work you admire. Choose photographers whose work you would like to emulate. Collect their pictures and measure your work against theirs. Strive to equal their work.

These are your photographic role models.

Analyze your model's pictures. *What factors make them successful?* The idea, the lighting, poses, color, mood, emotional impact, perspective, design?

Utilize these concepts in your photos. For instance, one key to Ansel Adams' scenics is that he achieves extreme illusion of depth by having all planes — close, middle, and distant — in sharp focus. Two keys to the work of Freeman Patterson are the use of muted color and careful consideration of design.

Be as objective as you can in comparing your work. Try to look at it dispassionately, as an outsider would. Where do you succeed, where do you fail? *(See Self-Critique.)* Be honest and strong enough to say, "This does not make it."

Why not?

This question is essential to learning and improving.

Be intelligent and objective enough to discard your unsuccessful pictures, or put them away for later comparison and to remind you how far you've come.

Your choice is to kid yourself and continue blindly on the same mediocre plane, or *to pull yourself up to the next higher level.* And the next. And the next. You can gauge your progress by continuing to compare your work with that of your role models. Almost before you know it, you'll be astonished how you ever looked on your early work as worthy of the light of day.

That's progress.

Creativity Strength and Weakness Checklist

Here is a checklist to evaluate your creative strengths and weaknesses. Use it as a guide to improve your picture making by *knowing yourself better.*

A weakness can become a strength if you identify it and work to overcome it! *Build on your strengths* and *overcome your weaknesses* through study and practice.

Refer to the definitions that follow this checklist and place a check in each column.

	Now		*Three Months Later*	
Creative Edge	Your Strength	Your Weakness	Your Strength	Your Weakness
Standard of Quality				
Expectations				
Dedication/Attitude				
Seeing Photographically				
Statement of Feeling (or Point of View)				
The Big Idea				
Previsualization				
Self-Expression				
Personal Style				

Technical Elements	Now		Three Months Later	
	Your Strength	Your Weakness	Your Strength	Your Weakness
Subject/Background Contrast				
Illusion of Depth				
Center of Interest				
Perspective for Impact				
Fine-Tuned Focus				
Selective Focus				
Movement				
Hyperfocal Setting				
Steadiness				
Special Color Considerations				
Format (Horizontal, Vertical, Square?)				
Composition				
Your Meter				
People Pictures				
Close-up Skills				

1. *Standard of quality.* Do you have high standards that you arrived at by studying the work of master painters and outstanding photo artists?

2. *Expectations.* Have you set high-level goals?

3. *Dedication/attitude.* Do you approach photography with a resolution to reach your creative and earning potential?

4. *Seeing photographically.* Are you consciously trying to develop a "photographic eye"; to see with fresh eyes; to see in terms of light and shadow, shape and form, color and design; to see in terms of composition, of impact; to reveal the hidden essence of the subject or scene; to see a picture where most others do not?

5. *Statement of feeling.* Can you put into words what you feel about a scene or subject?

6. *The Big Idea.* Do you search for the idea in a situation — something novel or different or important? Something that has a meaningful message, that imparts new information?

7. *Previsualization.* Before you release your shutter, can you visualize the photo exactly as you want it, framed and hanging on a wall or whatever its final use?

8. *Self-expression.* Are you able to capture on film how you *feel* about your subject or the scene before you? Isn't this the basic reason you are so involved in photography?

9. *Personal style.* Have you achieved a style that is unique to you?

10. *Subject/background contrast.* Are you always aware that a subject has most impact when visually separated from its background?

11. *Illusion of depth.* Do you utilize your creative controls to put the illusion of the three-dimensional real world on film?

12. *Center of interest.* When composing a picture do you successfully direct the viewer's eye to the natural center of interest?

13. *Perspective for impact.* Do you move around your subject looking for possible angles because you are aware how great a difference a camera move of a few inches or a few feet can make?

14. *Fine-tuned focus.* Do you concentrate on sharpness and understand all you can do to ensure it?

15. *Selective focus.* Do you have sharp/soft creative control that enables you to isolate the center of interest in your photos?

16. *Movement.* Have you practiced the many techniques for introducing the illusion of motion into your pictures? Can you use them effectively and appropriately?

17. *Hyperfocal setting.* Can you, if you so desire, produce an image that is sharp from here (very close) to infinity?

18. *Steadiness.* Do you know the slowest shutter speed at which you can hand-hold a given lens, and the numerous advantages of a tripod?

19. *Special color considerations.* Do you know how to control color so it enhances your message rather than detracts from it?

20. *Format.* Do you rarely shoot vertical pictures because it is such a bother to swing your camera around?

21. *Composition.* Are the principles of composition second nature to you?

22. *Your meter.* Have you checked the accuracy of your meter lately? Can you use it with precision to get accurate exposures every time? Do you have sufficient understanding of your meter to enable you to get expressive exposure?

23. *People pictures.* Have you incorporated the classic principles of portraiture so that your portraits, formal or informal, *reveal character?*

24. *Close-up skills.* Have you come to appreciate the visual excitement of ultraclose-up photography, and to successfully capture these mysterious images on film?

These subjects are all covered in this book.

Important: Check off your strengths and weaknesses, date the checklist, and set your goals. In three months go back and review your progress. If you have worked at it, you will have improved your weaknesses and enhanced your strengths. Your success will be in exact proportion to how hard you dedicate yourself to your expectations.

Caution: A strength can become a weakness. If you are good at some aspect of photography, you may concentrate on it to the exclusion of others. Thus, instead of becoming versatile, you could end up in a rut. You could become a formula photographer instead of improving on your strengths.

You are master of your own fate!

Evolving Your Talent

We all start from some point and develop as our talent evolves. You may have as much talent — unused and undeveloped — as the best photographers.

But your talent has to develop, step by step, just as theirs did.

The reason so few successful people are found in any field is because so few make the effort to evolve their latent talent. Everyone — but everyone — who has made it to the top has this in common: *They worked hard at it*, even if they were born a genius.

What may hurt your development is the fact that taking pictures is so deceptively simple. It seems there is no real need to work at it. A picture in 1/1000 sec! Someone with absolutely no knowledge of photography can buy a camera and within twenty-four hours have finished pictures! And probably "reasonably good" pictures, given the quality of automatic cameras.

Could you learn to paint a picture or play a melody on a piano in twenty-four hours? Think about the hours and weeks and years of practice to attain some level of skill! That's called "paying your dues."

How can you expect to master an art form such as photography with little effort . . . without paying your dues?

With effort your talent will evolve — step-by-step. The key is taking it step-by-step. Mastering photography is a progressive thing. You start with a foundation and build — *and build.*

Art vs. Craft

Photography is both art and craft.

Almost everything you've read focuses on the craft, often to the exclusion of the art. You use the craft to capture your feelings on film — *a relatively easy process* once you have mastered the simple creative controls of your camera. But it does little good to know the craft if you do not know the art. It does little good to have the skill to say what you want — but have nothing to say!

Very few photographers learn the art, which is why good photographers are such a rare and special group. *Yet almost anyone can learn the art of photography to create remarkably better images.*

Seeing photographically is the starting point of the art. It requires visual sensitivity to feel something special about what you see. And you need an understanding of the camera lens/eye difference.

Art is seeing and feeling. Craft is doing.

Walker Evans reinforced the point when he said: "Your mood and message and point have to come through as well as possible. Your technique should be a servant to that purpose."

Ansel Adams, in *A Personal Credo*, emphasized the concept and the craft when he wrote: "A photograph is not an accident — it is a concept. It exists at, or before, the moment of exposure of the negative. From the moment on to the final print, the process is chiefly one of craft...."

It is the successful combination of art and craft that gives you the Creative Edge.

Art and craft work together, but *it is the art that makes the difference.*

The photographer with the creative edge can make the most commonplace an art treasure. Reed Thomas understands his craft so thoroughly that he can adapt technique to create the exact impression he wants to portray.
"Bird Cage" by Reed Thomas

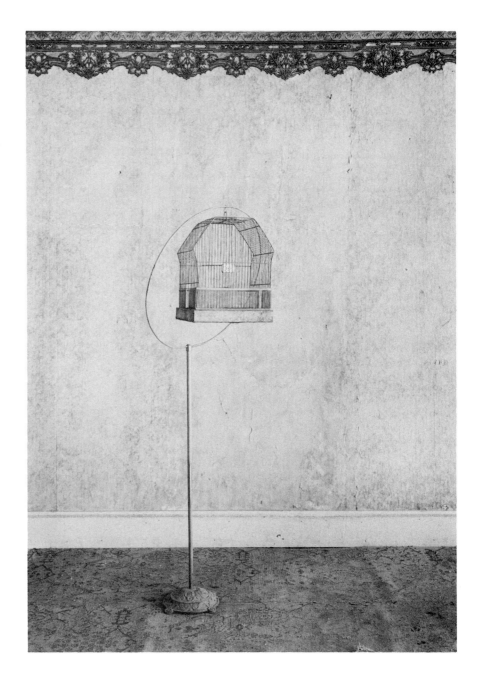

Section **2**

See Photographically

*I believe the photographer's eye
develops to a more intense
awareness than other people's, as a
dancer develops his muscles and
limbs and a musician his ear.*

—Berenice Abbott

An artist, Frederick Franck, author of *The Zen of Seeing*, was conducting a seminar for teachers and nonartists. When the conversation turned to "I can't draw a straight line" (read "I can't make good pictures"), Franck suggested an exercise. He had the students select a clump of grass, a leaf, a tree, or any subject and instructed them to look at it intently and then close their eyes for five minutes.

He then said: "Open your eyes and focus on whatever you observed... Look it in the eye, until you feel it looking back at you. Feel that you are alone with it on Earth... You are no longer looking, you are SEEING....

"Now take your pencil... and while you keep your eyes focused [on the subject] allow the pencil to follow on the paper what your eye perceives. Feel it as if with the point of your pencil you are caressing the contours, the whole circumference of that leaf, that sprig of grass."

The experiment was a success. Many of the students, to their amazement, captured the *impression* of their subjects — how they

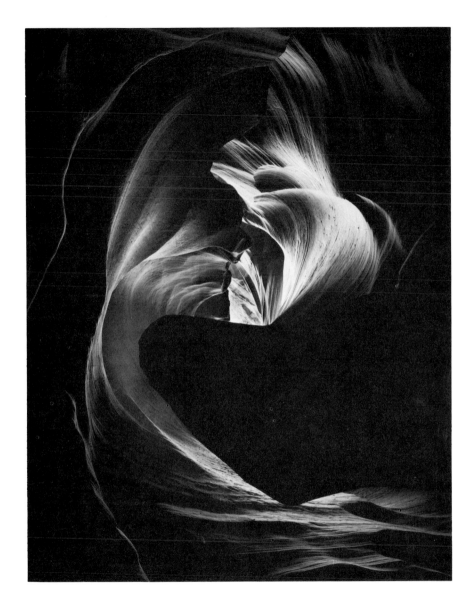

The most critical part of photography — seeing photographically — takes place before the shutter is released. Only by this means can you be assured of a negative capable of producing the desired effect. Previsualization of this scene led Bruce Barnbaum to employ an extraordinarily long exposure and compensating development to achieve this result.
"Circular Chimney, Antelope Canyon" by Bruce Barnbaum

felt about what they had seen. It proved how much deeper you can see with a little concentration, how you can feel something special and unique even about a leaf.

Brain Power

We often say that a camera is an extension of our arm. Thinking about it a little more, we say it is an extension of our eye. The fact is, *it is an extension of our brain.*

That's encouraging, because it has been said that we use only about 10 percent of our brain power *so there is virtually no limit to how well we can learn to see photographically.*

You could train for the rest of your life and never jump seven feet. But, with effort, you can use your brain to learn things that are total mysteries to you now. You can learn to read and write a foreign language, use a computer, read a blueprint, play a harpsichord, know the stars — almost anything you set your mind to!

You can also learn to see better photographically with concentration and practice. You must if you want to attain the Creative Edge.

Photographic Vision

One of the more prolific and wise writers on the subject of photography — from philosophy to technique — is Andreas Feininger. In his book *Photographic Seeing* there is this pertinent passage:

Specifically, it is the ability to realize potentialities — the potentialities of the subject or situation in terms of the picture: light, space, color, contrast, sharpness, blur... A photographer gifted with "photographic vision" sees his subject not only with his eyes, but also with the eye of the mind. He not only sees (in the literal sense) what's in front of his lens, but he "sees" what he sees also in photographic terms (i.e., he analyzes it): light and shadow, distribution of light and dark, color relationships and harmonies, perspective and depth, organization, composition... He critically evaluates his subject in regard to all the aspects of rendition: its photogenic qualities (which he will emphasize in the picture), its unphotogenic qualities (which he will try to correct or minimize), its latent possibilities (which he will try to bring into the open and utilize) — a more effective angle of approach, a different kind of view, a better way of cropping (in the viewfinder of his camera), a different scale of rendition, a more revealing kind of light.... He anticipates possible pitfalls: ugly perspective distortion, awkward overlappings of forms partly hidden behind one another, ungainly foreshortenings, embarrassing juxtapositions, the possibility of direct light striking the lens and causing halation and flares in the picture, contrast beyond the capability of the film, disturbing shadows, a phase of motion "stopped" at an awkward moment producing a silly-looking picture...

In short, a photographer gifted with photographic vision realizes that a picture is "made" BEFORE he releases the shutter (an act which only "fixes" what is already "made") because only before this irrevocable act can he exert control — "edit" his subject more carefully, correct objectionable aspects, modify, emphasize, add, delete, improve, or change his mind. Once the shutter is released, the die is cast, for better or worse, and what remains to be done can be accomplished by any competent phototechnician.

The purpose of "photographic vision" is to enable photographers to create pictures which, although produced by "machines," nevertheless express the essence of a subject in human terms . . .

Seeing Is Feeling. Ansel Adams, in his *A Personal Credo*, stated: "A great photograph is a full expression of what one feels about what is being photographed in the deepest sense, and is, thereby, a true expression of what one feels about life in its entirety.

"Of course, seeing, or visualization, is the fundamentally important element."

Edward Weston put it this way: "So in photography — the first fresh emotion, feeling for the thing, is captured complete and for all time at the very moment it is seen and felt."

John Szarkowski, Director of the Department of Photography at the New York Museum of Modern Art, wrote: "The photographer must have and keep in him something of the child who looks at the world for the first time ... very rarely are we able to free our minds of thought and emotions and just see for the simple pleasure of seeing. And so long as we fail to do this, so long will the essence of things be hidden from us."

Ernest Braun put it more succinctly: "Seeing is really recognizing and appreciating what's around us."

Don't just look — *see with fresh eyes.* Don't just glance — immerse yourself in your subject. Caress it with your eyes. Let it embrace you, overpower your conscious senses.

Then you are ready for the comparatively simple art of putting your feeling on film.

It won't work all the time, but when it does happen ... WOW! When that wave in your picture breaks on the rocks with an angry crash you can almost hear, when the lake is so tranquil you feel at peace with the world ... *you will have reached a new threshold of vision.* Rare indeed, yet attainable with practice.

Photo opportunities are waiting to be discovered, if you will but *feel them!*

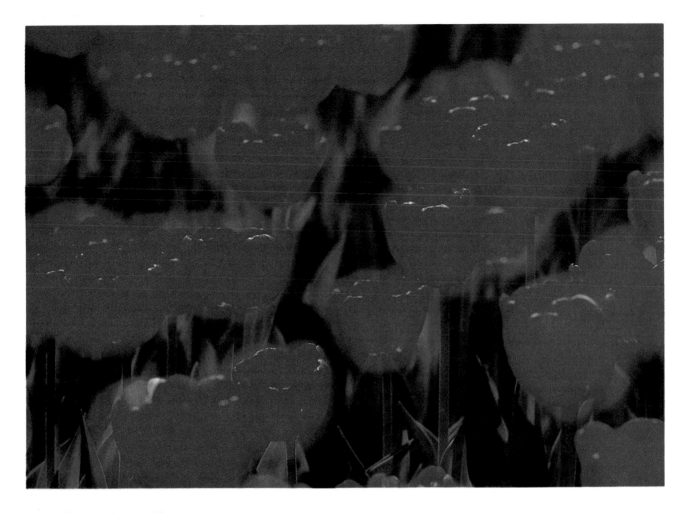

Any technique that enables you to turn your words into pictures is a good technique. In this instance, R. Hamilton Smith used a slightly off-register double exposure to create "electric tulips."
Photo by R. Hamilton Smith

*Here is one of Freeman Patterson's
spider webs displayed beautifully
as jewels along a silver strand.
Putting his emotions into words
allowed him to photograph the
web in a way that expressed his
true feelings.*
Photo by Freeman Patterson

Put Words to
Your Feelings

A milestone in photographic enlightenment was reached when Freeman Patterson put his feelings about a dew-covered spider web into words. In his book *Photography and the Art of Seeing,* Patterson tells how he had been photographing spider webs for years, but never got exactly what he wanted. Until one day when he put into words what he felt about these webs. He felt they were *"celestial jewelry."*

From that point on, it was a relatively simple matter for Patterson to apply his technical knowledge to put on film what he felt...because he was able to verbalize it!

When you are concentrating on making a photograph that is important to you, and feel something special about your subject (or at least a point of view), *try to put in words what that feeling is.* This act of verbalizing compels you to focus on and sort out all possible feelings, narrowing them down to one you can work with.

These words define what you want the photo to communicate. And they also tell you how to go about it!

I think this idea is so important that I suggest you read it again!

You feel something about a lake, and you are able to say that feeling is "tranquility." Now you've got it! All you have to do is rely on your mastery of your camera's creative controls and basic composition to make that scene tranquil.

"Tranquil" will dictate that you want a narrow, horizontal format because horizontal lines denote repose, quiet, calm. This in turn virtually selects your lens for you — wide-angle. A slow shutter speed will further quiet the water, maybe even make it misty.

A diffuser will further the idea. You may even decide to make

the scene pastel by giving it more light by opening your aperture one-half or a full stop.

Do you see how all this stems from your ability to put your feelings about the scene into words?

You feel the sea is "raging" or is "angry." Once said, you simply select the best way to make that statement.

Perhaps positioning yourself so that you isolate one great wave breaking against the rocks with a telephoto lens — stopped with a fast shutter at the crest of its power — will illustrate "raging" or "angry."

Think back to your last shoot, or to those slides or prints that disappointed you. How could you have applied this thinking in those cases? What would you have done differently now that you understand the relationship between feeling, the words that describe that feeling, and how those words dictate your creative options?

To see photographically and to be able to put your feeling or point of view into words... *that's the essential step that separates the photo artist from the gorilla and the 40 million snapshooters.*

Camera Lens/ Eye Differences

How many times have you seen a great picture in your viewfinder and your slides or proof sheets don't show anything even close to the original? For instance, you photograph a person and he turns out to be a small, insignificant object in a very large yard.

Can you count the times?

The difference is that your eye and the camera lens do not see in the same way. The eye continuously scans a scene in short impulses. These make up a mosaic that is put together by the brain

The human eye and normal lens have a similar angle of view that takes in the entire scene, even though your mind is able to isolate the figures on the screen.

The eye scans in narrow impulses and has the ability to shift focus to small areas. To match the eye's ability to see this TV caption, you have to change to a telephoto lens with a similarly narrow angle of view. This points up a common amateur error.

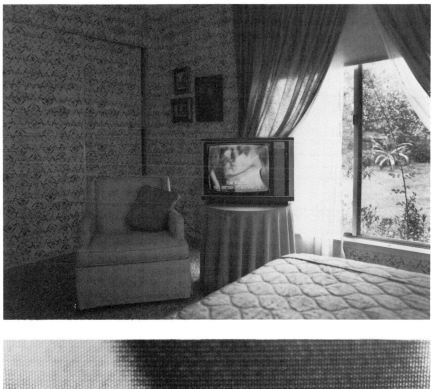

to form a whole picture. And since each impulse is a narrow one-and-one-half degrees, *the brain chooses to see what it is interested in.* In short — we possess selective vision guided by our brain.

As an example, look at the television set across the room. Focus on the face of the announcer. If you want to see a caption at the bottom of the screen you have to shift your focus from the announcer to the message. In even so small an area you cannot see both!

On the other hand, if you were to photograph this scene with a normal lens (which compares somewhat with the eye's angle of view) the camera lens will take in not only the announcer and the caption, but the entire section of the room!

Another difference is the ability of the eye to perceive the difference between a near object and one far away. This, along with our stereoptic vision, enables us to perceive depth. The camera lens, to the contrary, records a straightforward image on a single plane — producing a flat, two-dimensional picture.

The trick of photography is to make your lens zero in on what you see in your mind's eye in order to recreate the real world on a piece of film. This has to do with the lens you select and how you pinpoint the real subject of your picture.

To do this, you must apply the common-sense principles of composition, and master your camera's creative controls.

Making vs. Taking Pictures

People sometimes ask me what is *the* most important factor in creating good photographs.

There is no single answer. I could start with a general response about the importance of understanding the principles of art, an

awareness of the better photographers and their work, and, of course, personal photographic experience.

Yet, there is an underlying factor: a *mental set*, an *attitude* that compels you to make a picture rather than simply take a picture. I do not choose "take" over "make" arbitrarily!

Snapshooters *take* pictures. They simply take what is before them, discounting all the possible means of self-expression available to them.

Pros *make* pictures!

Making pictures means taking the time to appreciate and feel, to express those feelings, to attain creative fulfillment, to use the creative options that are at your fingertips.

Attitude. Linger a bit at a scenic "lookout point" and you will see many people drive up, jump out, shoot, and zoom off. These snapshooters are taking a picture (too often pronounced "pitcher").

Watch a while longer and you will see someone leave his car slowly, scrutinize the scene, thinking. With deliberation he selects a view, a lens, and maybe sets up a tripod. All the time you can tell he is savoring the scene and the anticipation of seeing it framed on a wall or displayed in a show.

This is a photographer making a picture...maybe even creating a picture! He has made a conscious, deliberate effort to produce the best image possible. His *attitude* governs the act.

But, don't get a guilt complex because you *take* a lot of pictures! There is nothing wrong with taking record shots (high-quality snaps) of travel, friends, family. These are memories to keep even if you do not have time or motivation to make these pictures to the best of your ability. Just don't confuse record shots with the art of photography.

Here are some guidelines for *making* pictures.

Creative Guidelines. *Beware of snapshooting.* There is a tendency to throw yourself into the fun of photography with the wrong attitude. The result is sometimes equal to the stuff the gorilla or 40 million others take. Enthusiasm can sometimes negate all the talent and training that set you apart from the snapshooter.

What you have (or should have) is *professionalism*...the ability to channel enthusiasm into increased perception.

Poise under fire, brothers and sisters.

1. *Photograph the subjects you like best.* Snapshooters rush into a shoot with camera loaded, shutter cocked, and begin shooting helter-skelter because they haven't thought out what they want to photograph or how to photograph it.

Photography is like a love affair. You do not want to lavish your attention and sensitivities on just anyone or anything.

There are a limitless number of subjects to shoot. Photography is *selective.* Make a list of photo opportunities and put them in order of preference. This will determine what you do and where you go to make pictures.

2. *Prepare yourself.* Think hard about each shoot: equipment needed, film, accessories, props, models. Learn techniques that will give you outstanding results. It's all been done before and someone has written books and articles about it.

3. *Involve yourself thoroughly.* When finally confronted with the opportunity to shoot, immerse yourself in the subject. Walk around it. Think about it. Look at it from all angles. Get into the Zen of seeing, which is really *feeling* — an ingredient you rarely if ever see in snapshooters' pictures.

4. *Shoot thoughtfully.* Slow down. Think about each shot. What effect do you want? What feeling does the scene evoke? Can you capture it on film?

Right there is the major difference between concerned photographers and snapshooters!

Don't be locked in by circumstances. Think of how your creative options can change what you see before you!

5. *Shoot in "sets."* That is, in series. Take events from start to finish. Take behind-the-scene shots. *Explore* the subject intelligently. Instead of having one picture worth framing or for sale or rent, you may have a dozen gems.

6. *Bracket your shots when you have a sure thing in your viewfinder.* The right subject at the right time is what photography is all about. When you see it, shoot it several times from several angles. *And at several exposures.* It's amazing how different (and sometimes better) a scene can be when exposed a stop over or under. A color shot underexposed one to one and one-half stops has a totally different emotional impact!

Bracketing is the cheapest insurance you can buy if the shot is important to you.

7. *Make notes.* If you are experimenting with a new lens, different film, a lighting setup you never used before, keep track of your exposures. It's a sure way to learn. If you plan to sell or rent your photos, record the four Ws — who, what, where, and when. Be brief. Be accurate.

As a serious photographer show your concern for good photography *by taking the time and consideration to make good pictures.*

Previsualization: Key to Creative Imagery

Quite simply, previsualization is the key to creative and expressive use of the medium...
— Minor White

I have come to understand something that has confounded me for years: *Why is it that two photographers can be shooting side by*

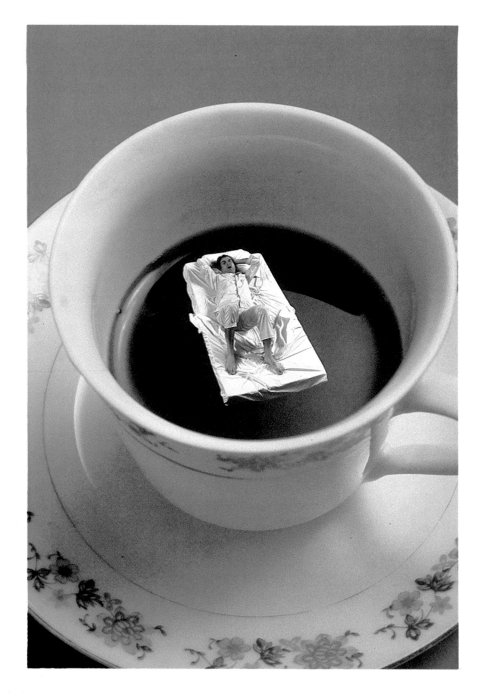

Don Carroll's special effect image existed first in his mind. With preplanning, Don's unique skill and technical competence, the image was captured on film. Photo by Don Carroll

side, with virtually the same equipment, and one comes home with prize-winning photos while the other with only ho-hum pictures!

Or to put it another way: You go on a field trip with a group and later meet to view everyone's photos. Some are okay, most are dull. A few are super, and many of those are surprises — objects and viewpoints others did not even see!

Why some good, some bad? Why or how did some photographers see what others did not? *What makes such a remarkable difference!*

I think it is because in photography there is such a wide latitude for personal vision, personal interpretation. We respond to things differently, and we *can* record those different feelings on film.

I emphasize the word *can* because, while only a rare few photographers actually record their personal vision, we all can.

And the way we do it is to apply what I believe is a paramount difference (a true pro difference). It is *previsualization*.

The photo of the man on the mattress in the coffee cup is from the book *Focus On Special Effects* by Don Carroll, a highly paid advertising illustrator in New York City. Actually, he calls himself a problem solver, and his specialty is special effects.

There is no way in the world this illustration could have been done without previsualization. Don saw this picture in his mind and then sketched it on paper. Once he previsualized the finished photo, Don's technical skill enabled him to make the picture.

You may ask, "Well, this technique is obviously the only way a special-effect shot can be made, but what about a family portrait or a landscape?"

Even a group shot should be previsualized before you make the exposure. Look, in the viewfinder and in your mind, at the completed and framed group portrait. Are the heads lined up in a monotonous row? Are there patches of conflicting colors? If so, you can take steps before exposure to correct such problems.

In more challenging situations, such as scenics and commercial work, previsualization gives you *creative control*. It's the point at which you use your mastery of your camera's creative options to bring to life what you see in your mind. It is precisely when a picture is made or lost.

It's what goes on in Ansel Adams' mind on a shoot. He said, "I see in my mind's eye something that is, literally speaking, not there. It is as if I had built up the image from within."

Think of all the photo opportunities that open to you when you can see something in your mind that may not even be in your viewfinder! With previsualization you can picture the world as it should be, or as it could be.

Remember you have fifteen creative options on your camera! With a change of shutter speed you can stop a waterfall or make it frothy and mysterious *(see Dealing with Motion)*. With aperture control you can bring all the planes of a landscape into focus *(see Hyperfocal Setting)*, or isolate one element *(see Selective Focus)*.

What other tools do you have? Lens selection, camera position, camera movement, to mention but a few. Beyond that there is postshoot manipulation: negative contrast, posterization, solarization, paper grade selection, even mounting and framing can help bring to life what you saw in your mind.

I want to impress you with this point: Probably every important shot by a pro is previsualized. Surely every commercial shot is. Previsualization separates the pros from the ams. And *you can learn it*. You can learn it by practicing!

Once learned, previsualization will multiply the effectiveness of all your other photo skills!

Creative camera controls and previsualization give us the ability to record images on film that do not exist in reality. R. Hamilton Smith knew where each image of this triple exposure would fall, and what the final effect would be.
Photo by R. Hamilton Smith

The Idea

It makes no difference what the subject matter is. The idea,
the statement, is the only thing that counts. — Aaron Siskind

All things considered, *a good idea executed less than perfectly is preferable to a technically perfect nonidea.* A good idea executed well equals a great picture!

Two examples of new twists to old ideas in this book are by Jim Zuckerman and R. Hamilton Smith.

Zuckerman's picture (page 43) is a simple photogram, a technique that has been around for about fifty years or more. As you may know, objects are placed on printing paper and exposed with the enlarger light in the darkroom.

Zuckerman used this technique with flowers on colored paper to achieve the feeling of a delicate watercolor painting.

Smith's photo (page 25) is a double exposure with the second, ghost-like image slightly off-register to produce "Electric Tulips."

These are good ideas — although not new — beautifully executed.

An idea can be simply the portrayal of the human condition, human emotion, the importance of a special event, contrasts of new and old, the grandeur of nature, human achievement — whatever you feel is important to say — as long as it is *stated with a fresh viewpoint or as a personal statement!*

The "bigness" of an idea can be measured by *how much it reveals, how quickly,* and *how novel the idea.* We could not get enough of the first pictures of man on the moon. Now such pictures lack the impact of novelty. How blasé we have become!

Truth and Beauty have always been big ideas. How rare it is to see pictures that depict them!

But to qualify as an idea, a waterfall or a flower or a portrait must be much more than ordinary. A big idea goes beyond ordinary vision.

Walker Evans stated it well. "...Unless I feel that the product (photograph) is a transcendence of the thing, of the moment in reality, then I haven't done anything..."

Portraits by Yousuf Karsh or Arnold Newman reveal a precious truth about their subject — *character.* Compare their work with the vapid, static, shallow pictures the public accepts as standard for many of today's studio portraits! *(See People Pictures.)*

Target your idea and *only* your idea. Be a surgeon. Cut out the unnecessary, the unsupporting details. Be ruthless. Zero in. Reduce your idea to its bare essentials, its clearest, deepest meaning.

Matisse said: "All that is not useful in a picture is detrimental."

Be energetic. Change positions. Change lenses. Use light and cropping in the camera to include details that support your idea, or to eliminate the superfluous. Don't let color seduce you into subverting your idea. Don't let color overpower the idea.

Be a bulldog. *Grasp the idea and hold on to it until you have it on film...* in its simplest, most profound form.

The idea behind the apparently unstructured work of Dr. Joel Walker, psychiatrist and photographer, is psychological. He found that these photos act as catalysts in therapy sessions with patients. Walker has shown his "See & Tell" exhibit in a number of cities and found significant cultural differences such as "the degree of feelings evoked and the ways they were expressed."
Photo by Joel Walker

The grandeur of nature is always a "big idea," especially when done with the consummate skill that removes it from the mundane.

This is one of the artist's best-selling photographs. "Basin Mountain, Approaching Storm" by Bruce Barnbaum

"Portrait — Man in a Stringy Brim Hat" is an imaginative and personal way Otis Sprow chose to portray the spirits left behind in an abandoned mental institution (one of a series).
Photo by Otis Sprow

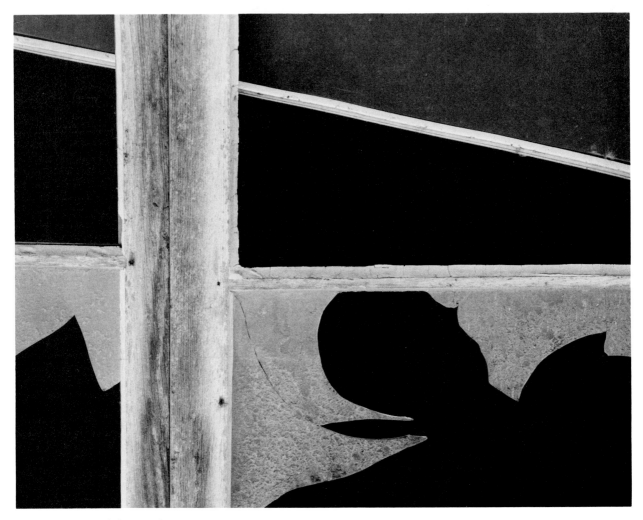

This picture is validation of an artist's ability to find an art idea in unsuspected places. John Sexton saw a strong interplay of pleasing shapes and full range of tones in a broken window that combine to make a beautiful abstract image. "Broken Window, Pescadero, California" by John Sexton

Jim Zuckerman's idea was to update an old technique — photograms — for a fresh view of a familiar subject. Only important elements are used; no distracting details dilute this impression of a watercolor painting.
Photo by Jim Zuckerman

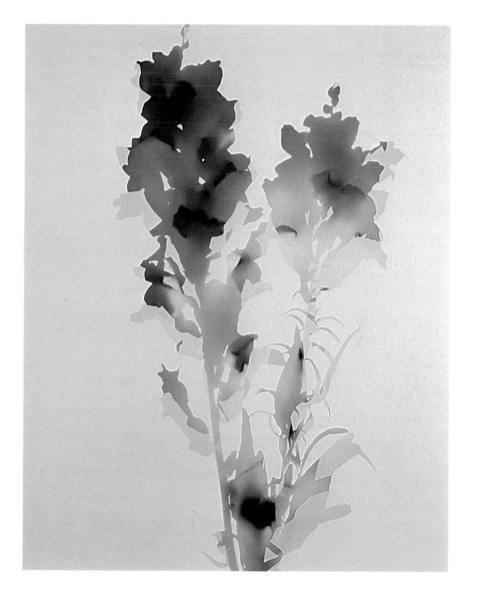

Create with a Pencil

Virtually everything that is created, especially in the arts, *starts with an idea on paper*. It may be a sketch or simply a list. But always — the essence of the idea on paper.

Sculptors, ceramicists, painters, designers, writers, historians, essayists all begin with sketches, notes, a plot, a goal, or a theme. And so do art directors, producers, and photographers, both professionals and serious amateurs. This is especially true for commercial assignments.

Imagine for a minute that you have an assignment to shoot the Eifel Tower. How can you approach the assignment as a pro?

Take pencil in hand and begin to list the different approaches possible. The bottom line should be a *viewpoint,* an *attitude,* a *statement* of what you want to portray about the tower.

Do you decide to show the tower as the physical hub of the city? Or that by size alone it dominates the surrounding area? Or your decision may be to demonstrate the tower's place in history.

As you explore each approach you will want to do *more pencil work* to decide what techniques and equipment you will need.

Let's reduce the Pencil Theory of Creativity to exaggerated simplicity.

You are going to shoot a common, ordinary, farm-variety egg. Here's how to approach it:

1. *Objective.* Do you want to emphasize the egg's design, its strength, its weakness, its vital sustenance value, the pleasure of eating it?

2. *Interpretation.* What ideas or sketches will you write down? Will you emphasize its unique design by comparing an egg to a brick, for instance? Prop an egg on end and put a weight on it to

Simple — even crude — sketches help distill the salient features of an idea and generate techniques for executing the ideas.

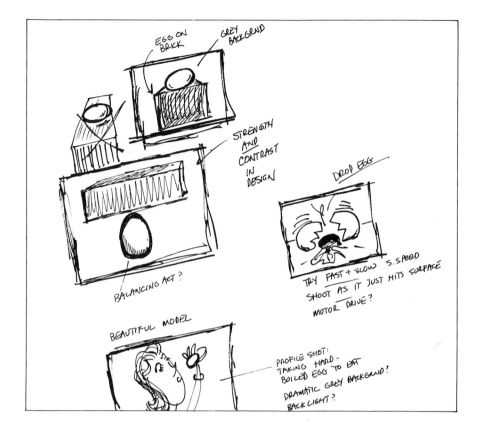

show strength? Shoot it as it breaks to show its fragility? Show someone eating eggs with gusto?

3. *Technical info.* To begin to put your ideas into action, write down the film you will use, the lens needed, props, lighting, etc.

It is not magic. It can all be done with a pencil and paper. It's the same for portraiture, scenics, still life, news. Take time to *plan* for every important photo shoot.

A pencil (or pen) is the only photographic tool I can recommend that carries a 100 percent guarantee that it will improve your photography.

So sharpen that pencil.

Facts of Light, Composition, Color and Other Matters You Can't Ignore

*The character and quality of a picture
can be altered by the character and
quality of the light.*

— Life Library of Photography: *Light and Film*

Facts of Light

It is simple, and inadequate, to say that light is the vital spark of photography; that without it there could be no photography, for photography is the result of light striking a light-sensitive surface.

If light were unchanging and fit all situations, there would be no problems in photography, no challenges — no art.

And since, thank the Lord, light is brilliant and muted, blue to pink and orange, beams from horizon to horizon and all degrees in between, understanding light and working with it to its fullest advantage gives you a wide, wide palette of creativity.

Light itself, in all its variations of quantity (brightness), quality (spectral or diffused), color, and direction, has a deeper and wider effect on photographic images than all your equipment combined. And then some!

It is an understanding of, and more important a *feeling* for, light that enables some photographers to get more out of an oatmeal box with a pinhole than many of us can get out of a two-thousand dollar system.

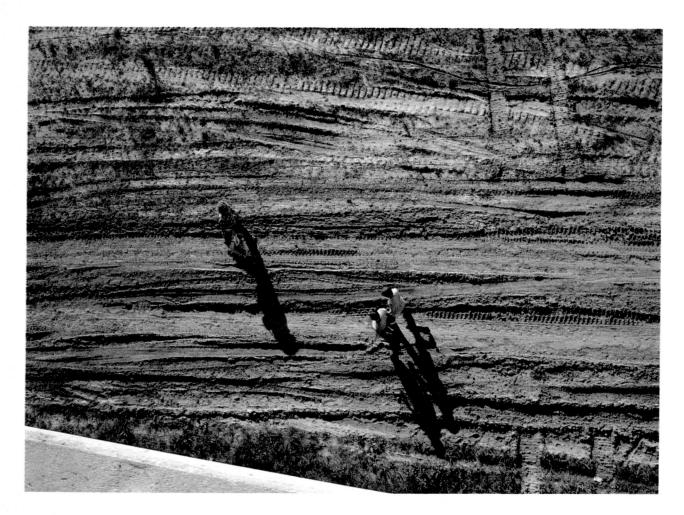

The photographer's high vantage point demonstrates how light direction defines the rich texture of the earth, artfully broken by elongated shadows of the passersby. Photo by Klaus Putter

The direction of the light falling on a subject has a strong, controlling influence over the final image, especially the detail. Straight-on front lighting (left) produces detail-less church at 8:20 a.m.

At 1:10 p.m. (right) light direction from the side emphatically renders every architectural detail through the contrast of highlights and shadows. (See also Shape in Composition.)

As you increase your sensitivity to light's descriptive powers, you will come to appreciate and use light's endless nuances.

Light says it all.

Direction. *Shape becomes three-dimensional form when light produces shadows, resulting from the direction of light.* (*See Fact of Light: 3D.*)

Light's direction also brings out character — character in the lines of a face, in the texture of an old church door, in the convolutions of a mountain.

Take a mountain for instance. A mountain's character is in its subforms, its rocks and crags and outcrops. With frontlighting these have little or no form. With sidelighting, every characteristic is etched in light and shadow.

One photographer's frontlighting is another's sidelighting, depending on which side of the mountain he's on.

If your subject is movable, move it to take advantage of

sidelighting or backlighting. If it is not movable, you move. If you are working with lights, move your subject or your lights.

When you look at a picture of any kind, note where the light is coming from and the effect it has on the mountain or person or boat or flower. This is as telling (maybe more so) of commercial photos as it is of scenics and portraits.

Shadows, of course, are your clue to the direction of the light source. Are the shadows long or short? Are they soft or sharp? Answers to the last two questions tell you if the light source is specular or diffused.

You learn a lot about photography by analyzing the lighting in pictures you like and duplicating it. (See Accurate Exposure.)

Fact of Light: Quality

George Tice first saw the oak tree at Holmdel, New Jersey, when it had no leaves. He came back months later and began to make what has become his best-known picture and biggest money-maker. His first exposure under a sunny sky was too contrasty. He waited, and forty-five minutes later made his famous picture.

A forty-five minute difference in time.

A world of difference in results.

It is not uncommon for photographers to wait hours in adverse weather, even wait for the seasons to change, in order to have the right quality of light. Good photographers are patient and have the ability to *not* shoot until the light is right.

Only God can light a landscape. But for smaller areas and subjects, like people and flowers, you can alter the quality of light — even the sun's light!

Quality of light governs the appearance of what you photograph.

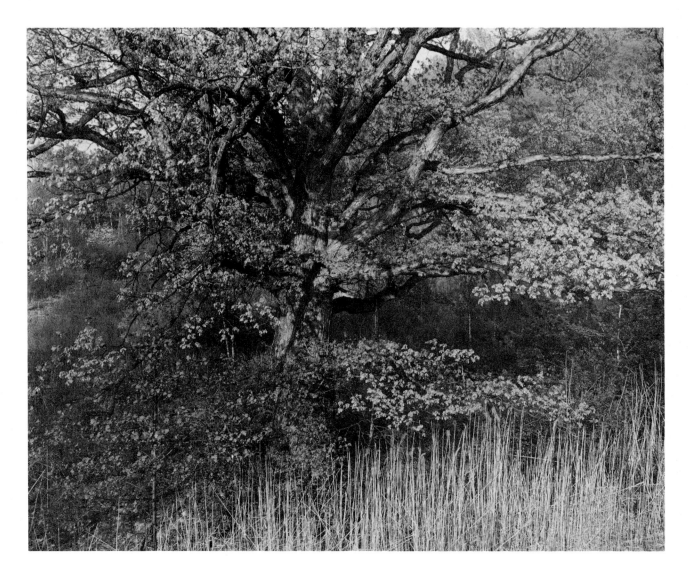

This is the first of two images of "Oak Tree" at Holmdel, New Jersey, taken by George Tice. Bright sun made the scene too contrasty, the subject too complex and graceless.

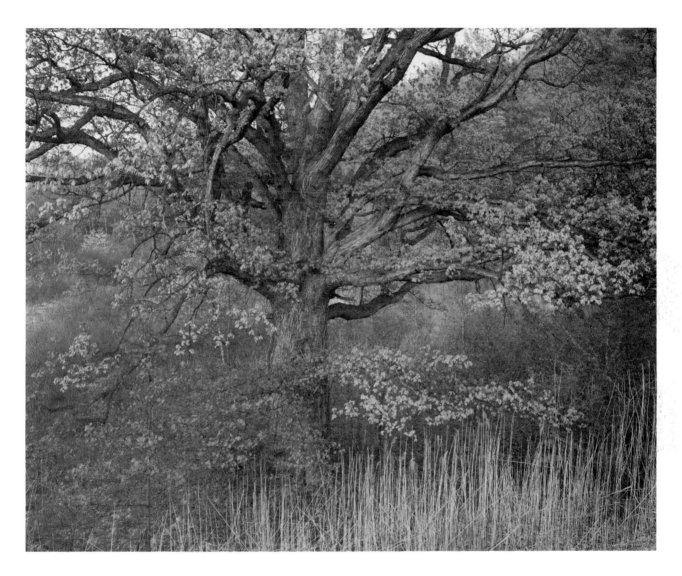

The same tree taken only 45
minutes later in low light after
sunset became Tice's best seller.
Note how the structure of the tree
is clearly visible; the image
simplified, strengthened, and
beautiful in its finely detailed
foliage.
Photos by George Tice

You have *two qualities* of light to work with, specular and diffused, and only one is best for a given situation.

Specular light is harsh and creates strong shadows. A spotlight, floodlight, flash, and the sun are examples. The closer the specular light to the subject, the less-pronounced the shadows.

Diffused light is broad, soft, and it creates slight shadows. Diffused studio lights, bounce light, and an overcast day are examples.

Light Controls. Patience is your first control, patience to wait for the light that will best express your intent, your feeling.

Energy may well be your second control, the energy to get up early in the morning or stay late to get the pictures that depend on rising or setting sunlight.

If your subject is movable you can place it in the sun for specular light. You can move it to the shade for diffused light.

You can reduce contrast and erase shadows with reflectors. You can shield a small object from the sun by shading it with your body.

Reduce contrast and light ratios by placing a translucent material between your subject and the sun. This is great for portraits. (*See People Pictures.*)

To absorb light and shield your subject from specular light (principally the sun), use a dark reflector such as black cloth or cardboard.

The point is that *control is in your hands.* But the idea for the picture begins in your head. Keep your mind and options open.

Color Quality. Light's color quality changes continually from sunrise to sunset. Each change paints a different picture and a different mood.

Because our brain knows the color of common brick (red), for instance, we tend to be unaware of the change in its colors. Yet a brick building may change from light pink to deep maroon within

the hours from noon to nightfall.

A photographer who is sensitive to these changes picks his time of day to shoot, principally for the mood he can capture.

Color Controls. Take advantage of the color of light by shooting when the light best expresses your mood.

Change your camera position so the light will illuminate your subject.

Adjust your aperture and/or shutter for more or less color saturation.

If you have a specific mood in mind and the light is not right, use an appropriate filter.

Filter Factor. Filters offer you many special effects and corrective options. Create a fog. Warm-up your exposure. Make the sky bluer.

With filters you can create a moody, indigo beach scene, a golden pond, an orange sunset where there is no sunset. You can place a filter over your flash for special effects. The possibilities are almost without limit with the new array of special filters from Cokin, Tiffen, and others.

Black-and-white photography has its own filters. Yellow filters darken skies slightly, red dramatically. Similar color filters lighten an object. Opposite color filters darken it. (Red is the opposite of green; blue is the opposite of yellow.)

What you want is what you can get!

All this having been said, there still is no substitute for the real thing — natural light at its best.

In an interview in *Kodak's Studio Light,* Fred Maroon was asked to explain the "almost magical quality of light" in many of his photographs:

"I like to photograph during the first or last hour of daylight. The French call it 'the exquisite hour,' and I find the low light absolutely gorgeous. It helps me to achieve nice rich colors, much better than bright sunlight."

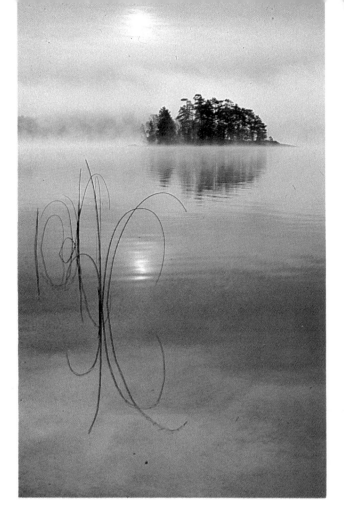

The same object can be recorded in a myriad of subtle colors over the course of time — the difference being the quality of the light — as we see in these two similar photos.

In the coolly toned photo, the reflection of the sun in the water tells us the light source is high and without color. In the warmer photo on the right, the film records the much warmer glow of the sun low on the horizon.

Photos by R. Hamilton Smith

Freeman Patterson uses both symbolic shapes and colors to make this evocative image. The tombstones repeat the shape and upward arching thrust of the church windows, a shape associated with religious and heavenward thought. The colors are a kind of reverse symbolism since we normally associate tombstones with death rather than in the warm spotlight that symbolizes life.
Photo by Freeman Patterson

Fact of Light:
3D

Since photography is the illusion of three dimensions on a two-dimensional piece of paper or slide, *whatever enhances that illusion will enhance your photographs.*

The toughest illusion of all to capture is that of form. How do you photograph a ball as a sphere and not as a circle? Or show that a storage tank has the capacity to hold oil? Or photograph a head so it is not a flat oval?

The factor that most affects our perception of volume is the *gradation of tone* — from light to dark.

In painting this is called *chiaroscuro*, the technique artists use to give roundness to objects and to the human form. *(See Facts of Light — Direction.)*

Imagine a ball with a white highlight near the top surrounded by a very light gray that gradually gets darker and darker (shading). At the lower edge of the ball, dark grays go to black. A shadow cast at the side of the ball heightens the illusion. Add a light reflection cast back into the very dark area and you have a perfect example of chiaroscuro.

This is how light works for you to bring objects to life!

Unless your feet are anchored in cement or the object is a mile around, you can look at it from every angle to determine from which camera position *light best creates form.*

Diffused light is best when you want subtle shading. That is why overcast days are so great.

Less-delicate shading is desirable to emphasize structural shape and detail. Therefore, if you are photographing a building whose shape and other architectural features interest you, you want specular light. You will have a picture with strong contrasts,

A three-dimensional effect is achieved through the proper use of light and resultant graduated shadows — the chiaroscuro effect. Learning to employ this effect of modeling with light and shadows will give your subject the illusion of volume and solidity.

making shapes dominant.

Lens selection is important too. A telephoto lens tends to flatten objects, while a short-focal-length lens increases the perception of depth and volume.

When you become sensitive to the many attributes of light, especially how it creates the illusion of volume, *you will acquire a unique ability* that will help you in every area of photography from scenics to commercial to portraiture. *(See Tone in Composition.)*

Think Composition

The purpose of art is to bring order to chaotic material, and thereby to create harmony. The main device for creating harmony is composition. Thus you create art photography through good composition in your pictures.

The true purpose of composition — aside from pleasing the senses — is to *lead the viewer through a myriad of elements* in your picture to your idea, your impression, your mood, your feeling, your point of view.

How important is composition? *New York Times* art critic John Canaday puts it this way: "Not every great painting is a great composition, but composition is so fundamental to the creation of pictures that a list of the world's greatest paintings would have to overlap a list of the greatest compositions. . . . Yet of all the elements in the art of painting, composition is usually the one least recognized even when it is playing a major part in one's reaction to a picture. By means of composition the artist directs the observer's eye, holds it on key areas, leads it away and back again, takes it slowly across some areas, quickly across others."

Effective composition is the major difference between an artistic

Composition — whether good or not — is always in operation. Its positive use permits you to control the viewer's gaze as his eye travels around and throughout the photograph. In this photo the eye keeps returning to the flowers which are placed at a point on the Golden Mean. The subject/background contrast further helps direct the eye to the point of interest.

Photo by Carol Cardwell

rendering of an idea and a simple record shot.

It is often said that composition is intuitive, a matter of "feel," and that there can be no rules because they would stifle creativity, leading to clichéd uniformity.

Yet, composition is a body of organized knowledge that can and should be learned. Dozens of good books have been written on the subject, but in the final analysis the principles of composition must be "internalized." *With practice it will become natural* — not simply a set of rules.

Henri Cartier-Bresson once wrote: "Composition must be one of our constant preoccupations, but at the moment of shooting it can stem only from our intuition, for we are out to capture the fugitive moment, and all the interrelationships involved are on the move."

Portraiture too requires that you consider composition. As Arnold Newman said: "The design elements and compositions had to augment the statement I wished to make."

You can absorb compositional principles by looking at a lot of photographs and paintings, studying composition, and shooting a lot of pictures. Gradually, *composition will become second nature to you*, especially if your photos are seriously critiqued by someone whose opinion you respect, or by yourself. *(See Self-Critique.)*

The Core of Composition. Here are some guidelines to reduce composition to its basics:

1. *Be sure the graphic elements of a picture convey one idea and one idea only.* Bruce Barnbaum refers to this as the "unifying thought."

I have asked photographers what they were trying to say in a given picture and been answered: "There was my beautiful child playing in the field of flowers. I wanted to show how beautiful she is, and the flowers too. The child and the flowers played off dramatically against the old wood of the barn."

This picture tried to make three statements and could not

succeed at any...not only because it was too complex a composition, but *the camera is not able to effectively focus attention on three different subjects on three different planes.* Not with impact.

A beautiful child in a field of soft-focus flowers is a simple statement. One picture.

A beautiful field of flowers with everything else subordinated is a simple statement. A second picture.

The child *or* the flowers in contrast to the weathered wood is a third picture. *(See Fine-Tuned Focus.)*

2. *Keep it simple.* The difference between an elegant woman and a dowdy one is that the well-dressed woman, observing the jewelry she is wearing, says, "What can I take off." The other lady looks to see what further ornamentation she can add. Simply, *understatement is always classic.*

"Clean your viewfinder." Look closely for details that can be eliminated. What elements detract from the single idea or mood or feeling you want to deliver? Consider color an element of composition and don't let it distract from the idea of the picture.

Observe the background, the foreground. Are there lines leading out of the picture instead of toward the center of interest? Are there bright spots that will attract the viewer's eyes from the center of interest?

Squint with one eye to reduce the elements to shapes. This sometimes reveals more than you see with both eyes open.

You may have to move your camera position. As Henri Cartier-Bresson pointed out, a millimeter of movement will make a difference.

Look at some of your best prints and, as objectively as possible, think back to the shooting and *ask yourself if all the elements support a single idea.*

Honest answers will guide you to a *higher plateau of creative, expressive photography.*

Composition Basics. Manny Katz, art director and instructor at Reseda Adult Education's successful program (Reseda, California), offers these ten guidelines to his students:

1. The biggest problem with beginners' compositions is the *"Bull's-eye" syndrome* — everything dead center in the frame. This practice leads to dull, static compositions that all look alike. Probably the main reason for this is that the camera's focusing prism is guess where? Dead center!

2. *Think of the image frame as a grid* divided into thirds vertically and horizontally. Where the lines intersect is a good spot for your center of interest. The rule of thirds applies to vertical or horizontal compositions. *(See Golden Mean.)*

3. Once you've found your center of interest, start eliminating distracting elements from the scene. *Mentally trace around your subject and analyze the things surrounding it,* such as branches, telephone poles, chairs. Don't forget to use your depth-of-field preview button. You can control some of these distractions by opening up your aperture and letting the background blur.

4. Remember that *your main point of interest should stand out from the background.* If you have a light subject, try to shoot it against a dark background, and vice versa. The eye will naturally seek the brightest and sharpest area of a picture, so make that your point of interest. Keep in mind too that the foreground can enhance the main subject and — if at all possible — should lead the viewer's eye *into* the photograph, not distract from it.

5. *Move in close,* fill the frame, and eliminate everything from the viewfinder that does not enhance your subject.

6. When looking through the viewfinder, *be aware of the lines and curves* you see in the composition. Leading lines enhance the main compositional theme of the photograph. The S curve is among the most pleasing compositional lines. Horizontal lines tend to be dignified with a feeling of strength. Diagonal lines signal

The line of buoys effectively leads
the eye to the point of interest
and the strong subject/background
contrast holds the eye there.
Photo by Klaus Putter

Strong lines direct the eye to the small main subject in this strikingly simple and highly creative z-figure composition. Photo by R. Hamilton Smith

movement and speed. Curves portray serenity and romance. And converging parallels give depth.

7. *Don't forget framing.* When shooting scenics, for example, try to include some foliage at the top or side of your camera position, even if you have to have someone out of camera range hold a branch for you. Generally these "frames" will be in soft focus to increase the illusion of depth.

8. When shooting buildings or monuments, try to *include people* in the scene for scale and interest.

9. When shooting action photos of moving subjects, always *leave more space in front* of the moving subject. This implies movement and direction and gives the subject room to enter the frame. The same holds true for portraits. There should be more room in front of the face than behind it, or the photo will appear off balance.

10. When photographing a group of subjects, it is usually best to *use an odd number* of them. Even numbers tend to look static; odd numbers are easier to group or arrange.

I want to add two guidelines to Katz's list. They are simple and especially effective when you are hard-pressed to change an ordinary picture to extraordinary.

The dominant element. No matter what the scene or subject, position yourself so that *one element dominates.* This element could be your main subject or only a supporting one.

Whichever it is, do not place it in the center of your picture. It should be off center. The larger and stronger and sharper it is, the further off center it should be placed to achieve balance.

What can you accomplish by moving your camera and "placing" one object in a dominant position?

1. You can change a static composition into a dynamic composition (compare the two views of the Sculpture Garden).

2. By making a near object dominant you create a frame that helps direct the viewer's eye to the center of interest.

3. Exercise your creative control by isolating the dominant object as your center of interest and keep it in sharp focus.

4. If the dominant element is not the center of interest, you can choose to photograph it in soft focus or in silhouette by using a larger aperture.

5. A dominant element in the foreground gives a greater illusion of depth.

Even though the S curve leads you into the above photo, it lacks a focal point and presents a somewhat confused image.

The second photo used a single dominant element, placed to one side for more dynamic compositional interest. In a situation like this you can control the degree of sharpness of the dominant element.

Most situations lend themselves to the technique of the dominant element. It will help you create an unusual photo in a usual situation. Even turn ordinary to extraordinary.

Try it. It's fun to face a commonplace scene and see how many different solutions you can find to create one or more successful images.

Symbolism. Think of someone showing you a picture of a sunset on the Nile, another in Moscow, and a third in Baja, Mexico, and you can't tell one from another. They all could have been taken at a lake in Minnesota.

Include an Egyptian ruin, the onion-shaped domes of the Kremlin, some palm trees in Baja, and you *symbolize the specific areas.*

What symbolizes Paris or your hometown or a ghost town or a special church?

Symbols can be less obvious. An ornate doorknob may symbolize the luxury of a mansion. A sculpture detail around a church window may symbolize that particular church's architecture. Rusted, weather-beaten farm tools may symbolize an abandoned farm. (Imagine photographing the farm using an old plow as the dominant element in the foreground!)

The trick is to identify what symbolizes the situation and employ that symbol in your pictures.

Reduced to its barest essentials, a photograph is made up of *shape, tone, and color.* Combine these elements and you have *form, pattern (rhythm), and texture.*

Visualize a simple subject such as a human body. No matter how it is photographed, even without tone or color, the subject is quickly identifiable by its *shape.*

Utilize light properly so that graduated *tone* (shading) is introduced and you have a three-dimensional *form.*

(See Lighting: 3D.)

Natural *color* adds realism.

If light is directed so that it reveals *texture,* the subject is almost touchable. Realism is further increased.

After you have been paying attention to the basics of composition for a while, it will become second nature to you, and your own style will begin to emerge. When you can sense that happening, photography starts to be deeply rewarding as well as fun. You will be able to compose the same scene in different ways.

Center of Interest. The message you want your photographs to transmit can be received by the viewer only if his attention focuses on what you want him to focus on. That point is the center of interest.

If the viewer's eyes jump from point to point, fixing on nothing, or worse yet, fixing on a spot you had not intended, he does not "receive" your idea. Your picture fails!

So a critically important aspect of composition is the Center of Interest.

The Golden Mean*. Centuries ago, Greek artists discovered that the eye tends to focus on certain points in a picture that are represented by points on a grid called the *Golden Mean* or *Golden Section.*

If you divide a space into thirds both horizontally and vertically, the *points at which these lines intersect* are the points where the eye most comfortably focuses.

By placing your subject or point of interest at these natural focal points, you have the greatest assurance that it will in fact be the viewer's center of interest. (*See Freeman Patterson's Tombstones, page 55.*)

The Golden Mean (or Rule of Thirds) is a convenient mental aid to strengthening your composition. It is particularly effective in moving your center of interest off dead center, the common "bulls-eye" syndrome.

*Technically, this is really The Rule of Thirds, but is universally called the Golden Mean, which is the term we will use.

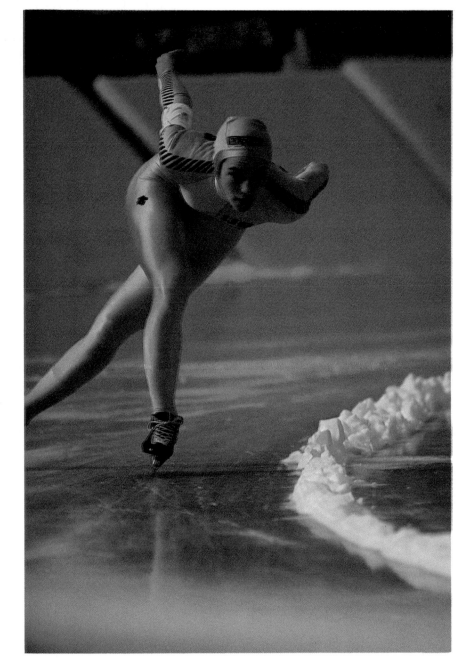

Learning to use the Golden Mean is easy. As you internalize this principle of composition, you can apply it to more dynamic shooting situations such as this racing skater. Photo by David Lissy

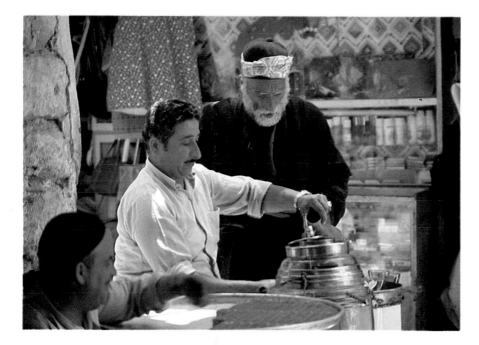

If you were to draw lines from the eyes of the men in the photo they would lead to the hand in the act of pouring, which is almost exactly one third from the right, one third from the bottom — the Golden Mean.
Photo by Ira Stanley

This slight asymmetry produces a more lively, involving picture and gets away from the "bull's-eye" syndrome that plagues about 89.92 percent of all photographs.

A commanding portrait style can be created when you place your subject's head a little off center with the eyes close to one of the points of the Golden Mean.

Other Visual Phenomena. The eye is attracted to the center of interest through a number of natural visual phenomena.

One is *visual movement.* Lines in a photograph can lead the eye to the subject — as a road leading to a barn. This is especially true if lines lead into the picture from the lower left (don't ask why).

The eye is attracted to the *largest element,* and to the *brightest element.*

One of the most obvious ways to isolate an element is to keep it sharp with everything else out of focus. (See Selective Focus.)

This photo demonstrates the effectiveness of the Golden Mean even in a starkly simple photo. Note how your eye gravitates to the Coke bottle, even though it is the smallest element in the picture. Photo by Manny Katz

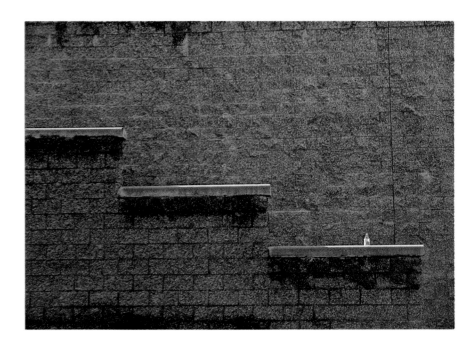

• A small object among several larger ones can often dominate — such as a puppy among several adult dogs.

• A small area of color will stand out against a field of contrasting color.

• A contrasting background is one of the most common ways to attract the eye to the center of interest.

• Anything that interrupts uniformity will attract the eye, such as a single white horse in a row of black horses.

• An object that is an entirely different shape will stand out, such as a cube among a spread of marbles.

Contrast in direction has impact too. Look down on a parking lot where all cars are parked squarely, except one, which is parked at an angle. You'll spot it even though it is one among hundreds.

Analyze photographs for the ways in which the center of interest is positioned, its relationship to other elements including color,

brightness, size, shape, direction.

To really grasp all the possibilities, take on a *self-assignment* to find or set up situations that demonstrate each of the above factors. *It's that important!*

Shape in Composition

A photograph starts with shape. All else builds on it, because it is the *fundamental structure of a picture.*

Shape is what we see first. More than any other factor, it *identifies an object.* There is no mistaking the shape of an elephant for that of a swan.

Your first obligation as a photographer is to help your camera record shape.

Shape is most discernible when it is

- Dominant in size
- Dominant in color
- In strong contrast with its background or field

Without tone or color, shape becomes silhouette.

Study the shapes around you — squares, rectangles, circles, triangles, and asymmetric shapes. Place a coffee mug on the table before you. Is its shape distinct? Hold it up against a background of cupboards or wallpaper. Move it closer to the background. Is its *shape more or less distinct?*

How does the mug's color differ from the background? What difference does the color make in delineating the shape?

Hold the mug up to the window and squint, visualizing it drastically underexposed by a meter responding to the strong window light. You will be seeing the cup as a silhouette. It is still

identifiable as a coffee mug.

Hold the mug so the light is from the side, and notice how it changes from a simple shape to a three-dimensional form.

If you really want to understand the importance of shape in composition, and how to work with it, do the exercises above with your camera, both without and with film.

What you learn can be used in any situation anywhere.

Tone in Composition

The gradation of color from light to dark is called *tone*. This is as true in black-and-white as it is in color, although it is more important in black-and-white. (Tone can also mean the lightness or darkness of a print.)

Knowing how to use tone allows you to express mood, helping your photographs communicate your feelings more fully.

A photo of overall dark tone (low key) can manifest quiet, loneliness, drama, or imminent danger.

A photo of predominant light tone (high key) can symbolize emptiness, coldness, but more often a pleasant, light mood.

This is not just theory. Think for a minute if you were photographing actors. One is a "heavy," a villain. You use dramatic specular lighting with deep shadows and an overall dark tone. Another actor is a clown. Surely you would portray him in a totally different ambiance — bright, cheerful, light in tone.

When you can, *match the tone of your picture with the theme.* Tone is not actually a physical part of a composition, but it is a psychological part of it.

Consider also the tonal values of other elements in your scene when composing a picture. Suppose you are posing a brown-haired

Tone is an important pictorial
modifier in black-and-white as it
is in color. Tone gives substance to
shapes as in these imposing
monoliths in Monument Valley.

Tone also shows depth and
perspective, becoming lighter as
planes recede in the distance.
Photo by Bert Eifer

beauty against a dark tree. The hair and the tree will merge in a color picture or a black-and-white, and you lose that critical subject/background contrast. Change perspective by moving to the side so your subject's head is no longer merging with the tree.

The important thing is to *previsualize* the effect of tone before you expose your film and not after.

Once you have previsualized, *you have creative options* to render your picture *lighter* or *darker* in overall tone. And you can make sure that the elements do not merge by adjusting the aperture and shutter. Change your position or that of your subject if possible. In the studio, change your background, bring in fill lights, remove a reflector, or shoot through translucent material.

Tone as Form. A shape that has tones graduating from light to dark takes on a three-dimensional *form* with fullness and volume. A rock is a two-dimensional shape, until tones give it highlights, midtones, shadows, resulting in a three-dimensional form. *(See Fact of Light: 3D.)*

The quality of light (specular vs. diffused) and the angle of light give variations to tone. Sidelighting, for instance, because it produces shadows, is an important consideration when you plan a shot.

Tone control with color film pales in comparison to that with black-and-white film. With B&W, employing the Zone System *(see the Zone System)*, you can vary your exposure with negative manipulation in mind — for greater or lesser tonal range (contrast).

How do you know how a color will register as a tone in your black-and-white print? Use a Kodak Wratten 90 filter. With it you see colors as tones from black to white (and all the grays in-between).

Tone affects your composition by giving form to shape and lending your pictures sensitive shades of meaning.

75

Pattern in Composition

It is natural for us to seek a harmonious arrangement of the many shapes, forms, and colors that confront us. This is called *pattern.*

Pattern can be used as pure ornamentation. As such it is one of few subjects in photography that does not require a point of interest, or adhere to other strictures of composition.

That is the delight of pattern. Without a point of interest the eye dances from point to point — with delight. Of all the compositional factors, pattern gives the most pleasure.

Pattern has rhythm, its own beat. Rhythm is the interval of repetition, as in music. And, like music, it should not rest on one note. Rhythm should vary with high and low notes, half and quarter beats.

A row of boat prows establishes a pattern. But if they are all equidistant, there is no rhythm. Two prows and a break, three prows and a break...now you're swinging with the beat!

Pattern is all around us: a row of trees, a row of roofs, a picket fence, the concentric circles of a seashell, a cobblestone street, an automobile grille. Close-up photography can show you a new world of pattern. For pattern in nature, you are best served by diffused frontlighting to emphasize pattern over form.

Keep pattern and rhythm in mind when you line up a number of people for a group portrait. Here you are dealing with similar shapes. Try to place them in a pleasing pattern. Start with three people and have them line up so their heads form a triangle. As you add people form another triangle. You are adding to the pattern and creating a rhythm of triangles that swing together.

Pattern is everywhere. Look for it and use it as ornamentation or as part of a picture for the pleasure it brings to photography.

This colorful paper fan typifies the sheer joy and exuberance found in a repeating ornamental pattern. The vibrancy of color results from processing transparency film in color negative developer.
Photo by Jim Zuckerman

The interlacing pattern cast by the steps which lengthen in rhythmic regularity contrasts elegantly with the clear side of the tank. This image would have less impact without the interplay of quiet space versus the patterned field. "Tank" by Otis Sprow

*Pattern on pattern and especially
the syncopated rhythm on the
right virtually makes this photo
visual music.*
"San Francisco, 1979" by Bruce
Barnbaum

One of the most compelling qualities of photography is its ability to portray textural surfaces. In this photo of a lichen-covered surface, Lloyd Webster shows how this phenomenon involves the viewer in your image, as simple as it may be.
Photo by Lloyd Webster

Texture in Composition

From infancy, we have an urge to touch things, to experience their texture. That is why texture in photographs adds so greatly to their illusion of the real world.

Fred Picker feels: "The sense of presence is increased in any photograph by the impression of touchable texture. The quality and direction of the light on various surfaces are so important that they can make a rough surface appear smooth in a photograph."

Including texture in your photos is one of photography's greatest challenges and one of its most satisfying accomplishments.

When you develop a sensitivity to and control of texture in your photos, *you invite your viewer deeper and deeper into your work* . . . to share your feelings.

Texture in photography is a tease. You should be able to almost feel the kitten's downy fur and the snake's glistening skin. And what different emotions those textures evoke!

You use light to "paint" texture just as the artist does when painting. Other textural controls include the grain of the film, the contrast of printing papers and film development (black-and-white).

Observe texture all around you, in streets, buildings, materials. Note the effects of weathering through rust, peeling paint, rotting planks, algae-covered stones. Notice how different textures work together: brick and wood, steel and glass. Explore the patterns of the ground, leaves, bark.

Take advantage of your macro lens and other close-up accessories to magnify what might otherwise appear to be textureless surfaces. (*See Close-up Fantasy World.*)

The quality of light affects different surfaces differently. Delicate textures will be more pronounced with direct, specular light from a

Extreme side lighting is the key to successfully using texture. The closer the angle of light as it skims across a textured surface, the longer the shadows cast, and therefore the more dramatic the high plateaus and deep valleys that are texture — whether of a door or a mountain.

Texture alone and the feeling it communicates can be the sole purpose of a picture, as it is here. Photo by Bert Eifer

low angle (crosslighting); rough surfaces will respond more to diffused frontlighting.

It requires patience to wait for the right outdoor light in order to get what you want. But with the right light, a heightened sensitivity to texture, and careful use of your equipment *you can create fascinating images — more meaningful illusions.*

Visual Design

As I have said, when it comes to art, we like what we know. We have artistic — visual — prejudices that narrow our photographic vision and confine us to shooting the same old stuff.

One art form you should become more sensitive to is abstract art — art made up solely of shapes and color. I call it visual design.

Visual design is mainly nonrepresentational, so you don't have to associate a given design with anything you know or don't know, like or dislike, or with any message. You just enjoy it.

Visual design is often a *small part of something larger,* such as an intricate and colorful pattern that is really an extreme close-up of a butterfly's wing. It could be patterns of light, reflections in water, the texture of moss. It could be an indistinguishable coral atoll seen from an airplane. Things that cannot be identified — and need not be. (*See John Sexton's "Broken Window" page 42.*)

Often people will ask what a particular visual design represents, and when they cannot identify it, they dismiss it. The point is, you don't have to "know what it is" to enjoy it.

John Canaday has written, "What you get out of it depends upon your sensitivity to its shapes and colors and their relationship to one another." To see visual design in the world around you requires the highest level of photographic seeing.

Knowing exactly what you are looking at in a picture is not necessary to enjoy the simple pleasure of elegant design. Color and shapes in pleasing juxtaposition (good composition) have no higher purpose than to delight the eye.
Photo by Bert Eifer

Visual design is not limited to abstract subject matter. This image celebrates the precise relationships of man-made forms. This carefully thought out composition and technical excellence in execution are testimony that line and shape (that can be found most anywhere) can be used to create outstanding photographs.
"Picket Fence and Window, Bodie, California" by Bruce Barnbaum

Visual design can often be discovered by looking at only a small part of a larger whole, such as this window shade. Cultivate a childlike awareness and delight in shape and color to uncover these rewarding designs.
Photo by Manny Katz

It is great fun to discover design both in nature and in the human imprint on our world. *The search inspires the imagination and will heighten your awareness of design, upsetting some visual preconceptions that may be limiting your creativity.*

Don't dismiss the visual designs in this book. Look at them with a relaxed, open-minded attitude. Do it again and again and soon, almost by osmosis, you will begin to develop a sensitivity for visual design. *Another world will open to you and help make the rest of your life richer! (See Close-up Fantasy World.)*

Horizontal, Vertical, Square

Should a given picture be square or rectangle, horizontal or vertical? We usually try to compose in the viewfinder so that no cropping is required later. But that is arbitrarily limiting. *The shape of your final picture should accommodate the shape of the image, even if you have to crop in the printing.*

The shape of the print can affect the apparent form of the subject. A tall church obviously calls for a vertical format. If you want a feeling that the church is tall and dignified, crop closely for a dramatically narrow, vertical picture.

The same church in a longer shot will not appear nearly as tall. Place the church in a horizontal format and it takes on a totally different dimension, a totally different importance.

Here are some of the effects format has on the *emotional impact of a photograph.*

1. *Horizontal.* This format communicates tranquility, peace, rest, open spaces. Don't divide your picture in half at the horizon; it becomes boring.

2. *Vertical.* The less-used vertical format reaches up, uplifting both subject and viewer. It lends vitality, dignity, and strength to subjects. You photograph a very important person from a low vantage point to exaggerate verticality, suggesting dignity and regality.

3. *Square.* A rectangle is more conventional than a square, which tends to be static. However, when you crop a rectangle to eliminate information that does not support the idea of the picture, you may have a square picture that communicates more. *Less is sometimes more!*

I have always wondered why the dimensions of slides are so sacred. Almost no one crops them. Often you can increase impact by cropping. Try Scotch-brand Polyester Film Tape No. 850, silver (or comparable). A roll will last a lifetime. Ask your camera store to order it, or check a hardware store.

Don't put a round picture in a square format!

The choice of presenting your photographs as vertical, horizontal, or even square rests partially on the shape of the subject, and partially on the emotional impact you want to convey. Format is an integral part of a successful final image as evidenced by the obviously wrong format in the above photo and natural format in the second.

The Special Considerations of Color

Color can be the dominant element in photography, and not always to the betterment of the art.

In the main, color is used sloppily — often without meaning and nowhere near its potential. It is used because it is there. The power it has to paint a scene with bold or subtle strokes is taken for granted and almost always underutilized.

Used correctly, *color transmits information accurately, realistically, emotionally.*

Far and away the most powerful force of color is its *emotional content.* In the biographical novel by Irving Stone, *The Origin,* Charles Darwin says, "Green is the most restful and satisfying of all colors." Dr. Adam Sedwick replies, "You're right, green is the color to unravel the knots of life's rope. Blue is colder, red more explosive, yellow turbulent...."

Nothing sets mood better than color. Study pictures that move you to discover the color ingredients that create the mood.

Black-and-white photographers have only black, white, and in-between tones to work with, and that is what makes B&W such a challenging medium. It is more abstract, depending mainly on strong composition and shapes sculpted from subtle tones. It is a more difficult and more intellectual medium.

A truly great color photographer combines the stringent composition requirements of black-and-white photography with the attributes of color. The key test: *Would the color photo be successful as a black-and-white?*

In this chapter I will highlight only the creative uses of color. The subject has been treated in detail in most books on photography. For a fuller investigation I recommend two books:

Sometimes film will react to weather and special light situations in strange and entrancing ways. Here there is an eerie mystery about the house, yet a glow of warmth. The charm about pictures like this is that they mean different things to different people, and you read into them whatever you will.
Photo by R. Hamilton Smith

This is a unique composition made up primarily of muted pastel colors that are close in brightness and have minimal saturation. How can it succeed as a photograph? It does. It has a uniquely subtle power that proves again that a keen photographic eye can see a subtle blending of colors as a picture where others cannot.
Photo by R. Hamilton Smith

91

The relative proportion of one color to another — and its location within the composition — has a substantial effect on the impact of color. Notice how strongly the boat stands out because of the color contrast and the positioning on the Golden Mean.
Photo by Walter Griebeling

Vision, Composition and Photography by Weber and *Color Design* by Mante.

The first mistake most photographers make in working with color is to consider it *the* most important factor — to the exclusion of composition. Color can bowl us over with sheer impact and emotional response to the point where we cannot see the content of the picture.

To the extent that you can control the situation, keep in mind that ideally a photograph should have *one dominant color.* Additional colors should appear subordinate to and supportive of the theme color. You'll see this in most outstanding color photos. *Note how many color photos in this book bear this out.*

On the other hand if your *overall scene* is a monotone or made up of just a few colors, these colors should vary from light to dark and include a good range of tones. In the event your scene's subject itself has a limited tonal range, it should be offset by contrasting colors to make it a visually interesting picture.

Color Control. Daylight comes in many colors, depending upon the time of day, the season, and weather conditions. A white object photographed at different hours could be pale blue, pink, or even orange; and if shot in open shade, a pronounced blue.

Light can wash out highlights or create shadows. Often you will have to make a choice: You can cut down the direct light with a diffuser or fill the shadows with a reflector.

Color film selection. Normally you use a daylight film for daylight and flash. Type A film is used for floodlights, Type B for professional tungsten. Each of these films can be used with any light source as long as you use the appropriate color-correction filter.

If you know the color properties of these films you can use the "wrong" light without filters for controlled results. Daylight film with tungsten light gives a warm-orange glow. Tungsten film used in daylight acquires a blue cast. Try it with a one-step

underexposure for an eerie, cold-blue feeling.

Film also has other color biases. Some films are warmer, some bluer. Some photographers carry several different types of film to handle various color situations. Most have their favorites. Ernest Braun prefers Ektachrome 200 because, for him, "It really brings the outdoors alive." Some films are best for specific colors, some best for monochromatic scenes. Your best bet is to try one film for a time and then another until you understand each. Then standardize on one or the other for given situations. *(See Exposure — Expressive.)*

Filters. Color-conversion and color-correcting filters can be used to change the color of the light striking your film. Consider a warming filter when shooting in midday white light, a light-purple filter to create a romantic beach scene, deep orange to help a weak sunset.

A polarizing filter increases the saturation of colors, especially when light is reflecting off nearby surfaces such as water. It will darken the sky when oriented correctly to the sun, and cut glare and reflection from highly reflective surfaces. *(See Filter Factor.)*

Understanding Color. Colors can be described as hot or cold, each with its own psychological overtones. Red denotes excitement, danger. Blues "feel" cold and evoke loneliness.

As a photographer, you should *be aware of the implications of color and apply them to your work.* If you are doing portraits, you would, for instance, suggest one color costume for a rock singer and a different color for an opera singer. Your props, background, and lighting should all have appropriate color themes.

Colors can be strong or subtle. Subtle colors, along with slightly diffused images, seem to create a greater empathy between viewer and subject. That is why "misties" are so popular for wedding pictures. *The tendency of inexperienced photographers is to overlook muted colors.*

Begin to look for subtle colors in nature. Freeman Patterson has his eye attuned to this. Study his work for a real treat and relief from color overkill.

Also look for pure colors, monotones, dominant colors, harmonizers, contrasts, clashing colors, spots of color that attract the eye, and colors which in themselves are graphic elements.

Color fidelity. Subtle or strong, a color should be rendered faithfully *(see Exposure — Accurate).* As a creative photographer you have options to record a color as it is, as a lighter pastel, or even somewhat deeper. These creative options result from your control of exposure as determined by your deeper feeling about what you're shooting. *As little as one-half stop underexposure and one stop overexposure will have strong effects on color.*

Reflected light. Avoid situations where reflected light negatively alters the color value of your subject. Your subject can be affected by light reflected from a nearby colored wall, from green foliage, etc. — accidentally or intentionally. This can happen when you photograph people in a room with deeply colored walls. It's especially true if you use bounce light because that light will pick up the wall's color and transmit it to your subject. Some photographers use pink and gold reflectors for people pictures to add a little flattering complexion color!

Color enters the picture in numerous other ways. You can posterize by developing slide film in color negative developer, and vice versa. You'll be surprised how the colors reverse. (*See Jim Zuckerman's photo on page 77.*)

You owe it to yourself to increase your color sensitivity, to understand how to match color to mood, to appreciate the nuances of color as well as its compelling power. *You have an artistic force to work with,* a force you can control if you believe you can. Employ it to its maximum.

Section **4**

Control: The Pro Difference

If there is one word to describe the major difference between an amateur photographer and a pro, that word is *control.*

1. A pro controls the *time to think* how he can turn an ordinary picture into an extraordinary one.

2. A pro controls his *camera's creative options.*

3. A pro controls his *subject* — in portraiture, photojournalism, advertising illustration. He even controls scenics with his ability to select the most worthwhile vistas and place himself in a position to take full advantage of the situation.

4. A pro controls his *environment.* He scouts his locations and moves until one suits him.

5. And a pro controls *light* under most conditions. It's obvious that, in a studio, light control is within everyone's command. But less apparent is the fact that a pro often can control natural light. *(See Facts of Light.)*

Example: Skilled flower photographers sometimes wrap aluminum foil around their lens barrel. With the sun backlighting the flowers, the foil acts as a fill light.

6. A pro controls his *emotions.* Through his sensitivity to the subject he is able to make a statement.

You control things effectively when you know what will be accomplished with the creative options at your command.

A winner controls his life. A loser is a victim of circumstances. Don't be a victim. Take control. Make things happen! *Control as many factors as possible* to help you be the photographer you can be.

That's the pro difference.

Mastering Your Camera's 15 Creative Controls

Your camera is a relatively simple machine, considering the marvelous, magical images you can produce with it.

Why is there such a wide difference between what the same camera can do in the hands of an unschooled amateur and a pro?

Most obvious answer: Very few of us see photographically or can put into words what we feel. But assuming you have learned these essentials, *can you translate onto film what you want to communicate?*

Do you have mastery of the fifteen creative controls of your camera that enable you to communicate photographically?

Here they are, with some of the creative options each control makes available to you. This is not a complete exploration of each control, but enough to give you some techniques you can exercise when you make pictures.

All these controls are part of most 35mm cameras and some medium-format systems. Fully "automatic" cameras are more limited in some areas such as exposure control, unless they can be switched to "manual."

1. *The camera itself.* Your camera is not permanently attached to your eye, nor does it weigh 300 pounds. It is highly mobile, as mobile as you are. *Move it.* Up, down, sideways. Crouch down and shoot low for a worm's-eye view. Climb steps and shoot down.

Look for dynamic perspectives. Position yourself to take advantage of the direction of the light source. A lens may cover only a few degrees, but you can cover 360.

2. *Lenses.* Lenses come in ultrawide, wide, fish-eye, normal, short or long tele, zoom, macro, close-up. These choices take you from here all the way to there. Handled with skill, your lenses allow you to shoot supersharp or to deliberately soft focus. Use your lenses for selective focus. Combine a small aperture with hyperfocal setting to bring both foreground and distance into focus. *Your options are unlimited! (See Selective Focus and Hyperfocal Setting.)*

3. *Lens accessories.* There are a myriad of things you can place in front of your lens for an almost infinite number of effects. Polarizing, color, and special-effect filters. Screw-on close-up filters, extension tubes, bellows, diffusion filters, vaseline, butter, matte boxes. Shower door glass and other materials to shoot through. *(See Filter Factor.)*

4. *Camera scales.* They are there for a purpose. They'll tell you how far you are from your subject, which is a big help with flash. You can also tell what will be in focus with a specific f/stop; this is important for zone focusing.

5. *Shutter.* You control the illusion of motion — from freeze action to blur. Your shutter is also one way you control exposure. (*See Dealing With Motion* and *Exposure.*)

6. *"Bulb" setting.* This enables you to keep your shutter open while your subject moves into view. Or move your camera (for a blurred effect), and then fire your flash to freeze the action on the same frame. (*See photo page 125 by Barbara Boros.*) Bulb time exposures are great for traffic blurs at night. Use them to photograph lightning or take a landscape by moonlight (as long as nine hours). (*See Dealing With Motion*).

7. *Self-timer.* A self-timer allows you to get into the picture. Use it when you fear you may shake the camera when pressing the

shutter release. If you need an extra hand to hold a reflector, use the self-timer while you do the holding (with camera on tripod).

8. *Mirror-up.* Many SLR cameras have a mirror-up mode which moves the mirror up *before* the exposure. This mode assures you of no possible jar when the shutter releases.

9. *Aperture.* Control how much of the scene is in or out of focus (depth of field — DOF) with your aperture. Control the degree to which diffusers, etc., effect the image (the larger the aperture, the greater the effect). Control exposure from light to dark. *(See Exposure.)*

10. *DOF preview button.* One of the most useful but least-used controls is the DOF preview button. Try it at different apertures and see the effect exactly as it will be recorded.

11. *Meter.* The meter is perhaps your most critical creative control. As an artist mixing paint, you can match a color, supersaturate it for impact, or tone it down to a romantic pastel.

For black-and-white film, you may want to over- or underexpose and then manipulate your development time. For color, do you wish to hold the highlights or let them blaze? Do you follow the rule of thumb to underexpose transparency film and overexpose negative film? Or do you violate the rule for impact?

(See Exposure for more on this interesting and largely unexplored subject.)

12. *Rewind.* Have you overlooked making double exposures by rewinding? You can shoot two or a dozen exposures on one frame. You can shoot a roll of moon pictures, for example, remove the film, store it in the refrigerator, and later reload the roll and use it again to add images.

13. *Flash.* Flash comes in many forms: direct, off-camera, bounce, fill, stop action. Mix flash with other light. Use color gels. Use more than one flash. *(See Bulb, No. 6.)*

14. *Film.* Check your options. Color transparency (slides) or color negative, black-and-white, photomicrography film, infrared (color

and B&W), high-contrast, 1000 ISO Recording Film (with handsome grain), small- or large-grain films, duplicating film, daylight, tungsten, fast, slow. Select a film for color bias to create mood. And more. *(See Exposure-Expressive).*

15. *Tripod.* While not actually part of your camera, in many cases a tripod should be. For concentration and control, most serious photographers use a tripod for important shoots. Use it for steadiness with a long lens and slow shutter, and you can even kick it for effect while exposing! *(See Steady as You Go.)*

What I hope to impress you with by listing your creative controls is *1) you have them, 2) they make a difference, 3) they are your creative options to use for remarkably better photos.*

P.S. Read your camera instruction book at least once a year. You will relearn things about your camera you forgot, or didn't learn in the first place.

Subject/Background Contrast

Subject/background contrast *is one of the most important composition considerations...* another factor you can control!

A subject can best be seen for what it is when it stands out from its background.

The eye instinctively (in 1/100 second) isolates one subject in a scene. The surrounding area becomes the background. It is your job to arrange your photograph to accommodate the viewer's vision *by making sure there is good separation between the subject and the background.* Otherwise the photo fails.

With this consideration in mind, note that a subject has greatest impact when it is in its *simplest, most easily identifiable form, and in strong contrast with its background.*

You can easily see the importance of subject/background contrast in this photo. Cover the bottom half and you see a graphic example of how easily a subject can be read when there is strong contrast.

Cover the top half and you see that the tonalities of the subject and background are too close and present a confusing jumble. How would you shoot this statue to make it a clearly defined entity?

The following factors affect the subject/background relationship:

1. *Contrast.* Dark subjects on light backgrounds, or vice versa, as well as color contrasts, create the most definition.

2. *Size of subject.* The larger the subject, the more it will dominate the background.

3. *Position of the subject.* By moving your subject (when possible), or changing your camera angle, you can remove the subject from a background that fights for attention or sets up "background noise."

4. *Brightness of subject.* The eye tends to go to the brightest area of a picture, which, if possible, should be your subject.

5. *Lighting.* Sidelighting or backlighting on the subject will provide greater subject/background contrast.

6. *Relative sharpness.* The eye is also attracted to the sharpest point in a picture. By keeping your main subject sharp and background soft, you enhance subject/background contrast. *(See Selective Focus.)*

Take these considerations into account when you are previsualizing. Make adjustments that are as simple as moving your subject or yourself. As example, a candid portrait of a football player will read much better if he is isolated against the sky, rather than against a confused background of bleachers.

Position yourself in relation to the light source for sidelighting or backlighting.

Select a long lens that will isolate the subject. Use a shallow depth of field to soften the background. *(See Selective Focus.)*

There are always solutions if you know your objective and your equipment.

Perspective for Impact

When you present a subject or scene *taken from an unusual position,* your photo gains exceptional impact.

Almost every picture we see is taken from the photographer's standing position. Few photographers seem to be able to bend, kneel, or climb to shoot. Thus, any viewpoint that departs from the monotonous norm can be impactful and sometimes jolting.

What creative control could be simpler?

I have seen a photo of a frog photographed from *beneath.* Now

*The use of perspective leads to
photos of great apparent depth.
The one-point perspective in this
photograph draws the eye
relentlessly from foreground
to infinity.
Photo by R. Hamilton Smith*

This unusual view from above provides a refreshing change from the norm. When seen from a new perspective, objects often have a more graphic and abstract quality. Photo by R. Hamilton Smith

that is a slight shock to the system. The photographer had placed the frog on a sheet of glass and taken a worm's eye view. I keep this picture in mind to remind me of the *opportunities that exist when I change my picture-making position* — even a few feet up, down, or sideways.

Camera Position. A move of a few inches can make a difference in perspective; a few feet can make a dramatic difference.

One API member who travels extensively always comes back with outstanding photos. One of his techniques is to shoot down from buildings, bridges, stairways, or roofs. The *aerial perspective* gives his pictures interest others lack.

In his book *The Fine Print*, Fred Picker gives as concise a formula for camera position as you will find:

In photographs of still subjects, a good way to locate a camera position that will result in a strong expression of the scene is to 1) assume that you are in the wrong place; 2) walk slowly around the subject with one eye closed looking hard at the changes that occur as foreground forms move closer to, touch, cross over, and then reveal again the elements in the background; 3) then, when you feel you have found the direction the photograph might be best taken from, walk toward the scene along that line still looking carefully as extraneous detail is obliterated underfoot and all around; and 4) when you have found the distance that feels right, 5) do a slow deep knee bend to find the proper height. All of the forms will change relationships drastically. Carefully study the scene with one eye closed. Your quickened pulse will tell you when order has appeared out of chaos.

George Tice puts it this way: "When I am photographing a landscape, first I choose the perspective. Then I select a lens to fill out the composition. If I did the opposite, selected my lens first

*This successful commercial shot
was taken from standing height.*

*Simply take a lower angle of view
and see how much more dramatic
the image becomes! The moral? To
add excitement, bend your
knees — either get lower or
climb higher.
Photos by Tom Campbell*

and then walked closer to fill out the composition, I'd be changing perspective."

Only a careless or uncaring photographer leaves perspective to chance.

Selective Focus

A simple and effective way to express your feelings photographically is with selective focus. This creative control enables you to completely alter your composition by emphatically *isolating the center of interest in your pictures.* With selective focus you tune out visual "noise."

Ernest Braun uses selective focus extensively. "It's more natural.... My theory is that this is effective because our eyes focus selectively."

By changing your point of focus, *especially at maximum aperture* (shallowest DOF), you can shift sharpness from one plane to another.

This technique works with any lens, but the longer the lens (and the wider the aperture), the more selective you can be.

Creative Options. Selective focus enables you to separate your subject from its foreground and background, *blurring everything other than your subject* (depending upon length of lens, distance from subject, and f/stop). This gives you better subject/background contrast and a greater illusion of depth.

Even a distracting background can become visually exciting and colorfully supportive of your subject when it is out of focus.

A disturbing foreground can become mysterious and ambiguous. Shapes can appear as soft silhouettes that serve to frame the subject.

With selective focus techniques, you control foreground/background sharpness. In this case it is used in a most unconventional and arresting manner.
Photo by R. Hamilton Smith

*Selective focus is also an effective
tool to add apparent depth to your
photos. This picture demonstrates
how a small but important
element in your composition can
get unusual attention. Notice also
the placement of the turkey's head
at the Golden Mean.
Photo by R. Hamilton Smith*

Out-of-focus foreground colors can also enhance the subject. In portraiture you can place a colorful prop (such as flowers) in front of the camera and shoot through them. Again, to what degree they appear as flowers or blobs of color *depends upon how you control selective focus, with greater or less DOF.*

Under bright illumination, in order to use a wide aperture, you may have to cut down the light entering your lens by using neutral-density or polarizing filters.

When using your widest aperture, what you see in your viewfinder is what you get. If you close down, use your DOF preview button to see how the final image will be recorded.

Selective focus is one of the easiest controls for you to master. As the term implies, your control is selective. Once you have visualized what your center of interest can look like with different planes sharp or blurred, *selective focus enables you to transfer your mental image to a film image.*

Illusion of Depth

You photograph a scene that starts at the end of your lens and ends ten miles in the distance. You compress it into a little chunk of film, and finally onto a small piece of paper or a projected image on a flat surface.

The real world on a few square inches of paper?

A primary goal of photography is to create a 3-D illusion of the real world. *The extent to which you are able to create an illusion of depth is the extent to which your photography succeeds.*

According to Ernst Weber in *Vision, Composition and Photography,* these are the factors that determine this depth illusion:

1. *Illumination.* Shadows define depth.

2. *Fore/middle/background.* Artists have long created depth in pictures through the use of these relationships. Ansel Adams invariably uses these three planes in his landscapes. Ideally, a silhouetted subject in the foreground, focus on the middle-ground, and less distinct background imitates the human eye response that spells three dimensions.

One of the simplest devices for gaining depth is framing. Position yourself so that a branch of a tree, a person, a statue is close to your camera. For greatest optical realism this object should be out of focus or a silhouette.

When we see one object partially overlapping another in a picture, we understand that it is behind the other, farther away.

3. *Perspective.* We know distant objects are smaller, less clear, and that parallel lines such as railroad tracks converge.

4. *Texture gradient.* Texture in structural elements such as bricks in a wall and fence pickets converge and get smaller.

5. *Distance perspective.* Atmospheric haze becomes more intense and bluer as distance increases, causing distant objects to become more obscure.

6. *Cultural conditioning.* We know objects in pictures are "real" and have "depth" from picture books we have seen since childhood.

There are times when you have to arrange a scene or position yourself in such a way as to introduce the illusion of depth.

For example, when photographing a building, you may be able to move so that, instead of the sun hitting it straight on, the sun is at the side. Thus, you use the shadows to give the building definition — depth. You can also create an "overlap" of buildings by moving your camera position, further enhancing the illusion of depth.

You have creative controls that enable you to use these depth factors... to put the real world on film.

Here again is an example of one-point perspective to create an illusion of depth in a series of receding arches. Is there any question in your mind that it would take minutes to walk the length of this hall? "Lay Brothers' Refectory, Fountains Abbey" by Bruce Barnbaum

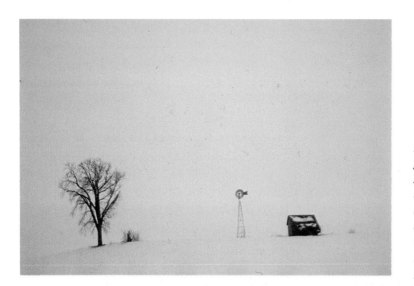

Overlapping planes also create an illusion of depth as these two photos illustrate. The photo on the left lacks an effective sense of depth because all objects are essentially on the same plane, compared with the second photo with the fence overlapping the distant objects.
Photos by R. Hamilton Smith

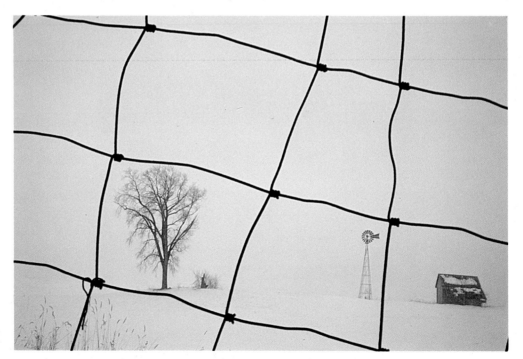

Hyperfocal Setting:
You Can See Forever

Why is it that a landscape done by a professional often has absolute clarity from very close to infinity, when yours sometimes has soft focus in the distance or more likely in the foreground? Unless you purposely want soft focus, you should know about hyperfocal setting.

- When you focus on a given point, more of the area beyond that point is in focus, and less of the area in front. The ratio is about two-thirds to one-third.

- How much is in focus is a function of your aperture. The smaller your aperture, the farther the area of sharpness extends — both in front of and behind the point of focus.

Hyperfocal setting is rarely covered in books or magazine articles, but when it is, it is always in terms of the three engraved scales on your lens barrel. Coordinating the f/stop scale, the focusing scale, and the DOF scale is difficult to comprehend — and unnecessary.

To achieve hyperfocal setting in any scene — from landscape to group portraits, crowd scenes, table top still life — *simply focus on a point that is about one-third of the way into the scene.* Use your f/stop setting to control how much of the image is sharp and how much is soft.

Prove it by using your depth-of-field preview button on your normal lens. Focus one-third of the way into a scene at f1.4, then at f8, and finally at your smallest aperture, f16 or f22. As you stop down, the image in your viewfinder will become darker. At f16 you may not be able to make out what you are seeing, but you can bet your Nikon everything is sharp!

Jim Zuckerman utilized hyperfocal settings to maximize overall sharpness in this image of Monument Valley. This technique will give you sharpness from here to infinity!
Photo by Jim Zuckerman

The real proof is in the proof. Shoot a roll of film as described above and look at your proofs. Better yet use slide film. When you project your slides it will be a revelation! You will incorporate into your mental computer, *sharp/soft focus creative control for every shot you ever take henceforward!*

Fine-tuned Focus

The number one photo imperfection is soft focus — resulting from not focusing precisely and camera movement. After you've solved these simple problems, your focusing ring and shutter speed become partners in creativity.

It is surprising how few images can be enlarged beyond 8x10 and be pinpoint sharp. Wall decor? If you are not tack sharp, forget it!

The basic problem is simply *not focusing sharply.* It may be poor eyesight (correctable), sloppiness, or downright not caring.

Or not understanding that you can *creatively control* how sharp or how soft different parts of a scene can be.

For people pictures, nothing is more important than sharpness and nothing reveals poor focus more than do eyes. When shooting, focus on eyelashes. In dim light, the mouth is a good substitute.

When shooting sports consider *zone focusing.* Select a point where the action is sure to take place — second base or the turn of a racetrack. Prefocus on that point, and when the subject *just begins to enter your viewfinder, shoot.*

The cure for camera movement is, of course, steadiness, along with fast shutter speed and/or fast film. *(See Steady as You Go.)*

Now for the creative opportunities.

1. Camera aperture. Outside of lens selection and how sharply you focus, your aperture determines what is in focus and what is not. In my opinion, *this is your most creative option.* Learn to control it, and you will open yourself to all kinds of photographic adventures.

Controlling depth-of-field is your most decisive control and should be considered on every single frame you shoot, *after you know the necessary shutter speed.* DOF is sometimes called *depth-of-focus* because, as your DOF increases, your apparent sharpness increases. At f16 or f22 (how about f64!) you can be a little off on your focusing and still have a sharp image. *With a small aperture you must compensate with a proportionately slower shutter speed,* increasing the danger of camera movement. (Another instance where a tripod can make or break a picture.)

In the example I gave of the man photographing the child, the flowers, and the side of the barn *(see Think Composition),* his f/stop could give him many options with which to shift visual emphasis.

Depending on lens selection and distances between subjects, he has these choices: child in focus, all else out of focus to varying degrees; flowers only in focus; barn wall only in focus; child and flowers only in focus; flowers and barn wall in focus; everything in focus.

Further creative options: child in focus, flowers slightly out of focus, or flowers a mere blur; child in focus, flowers in soft focus, and the barn wall simply a color blur — all made possible through aperture control!

Can you think of other creative possibilities?

It is easy to familiarize yourself with DOF. Shoot a lot of pictures with one lens, recording the f/stop for every shot. One roll of film done in this manner ought to give you a handle on depth-of-field abilities for that one lens. *(See Shoot a Roll — Learn Creative Control.)*

2. Distance from subject. Even if you use a wide aperture (shallow DOF), subjects will be sharper the farther away they are. Example: You photograph a landscape at f5.6 focusing on an object in the middleground. Distant objects will be from sharp to fairly sharp. Close objects will be less sharp.

The same f/stop for a close-up of a person will have the figure in focus, but anything in front and behind will be out of focus. More extreme would be a macro close-up, wherein the petal on which you focus will be sharp and everything else out of focus. (*See Close-up Fantasy World.*)

You will gain a "feel" for each lens by working with it exclusively for a time. Thus you will know how to use each lens for maximum creative control.

3. Shutter speed. The shorter the exposure, the less the risk of soft focus due to movement (yours and/or the subject's). At times, the event before you dictates the required shutter speed, so let the DOF fall where it may.

Photography is always a balance between shutter speed and aperture — on both a mechanical and an aesthetic level. Stop movement and live with a shallow DOF? Or risk blur for the sake of a deep DOF? Where the shutter speed can be as slow as you wish, let your DOF selection dictate what your picture will look like.

The longer the exposure, the greater the risk of soft focus. So when you can use a relatively slow speed, and want a deep DOF, use a tripod or monopod. *(See Steady as You Go.)*

4. Lens selection. With a 24mm lens you are in focus from three feet to infinity (at f22). With a 400mm lens, only the eye of the tiger will be sharp. Each lens has its own DOF; the wider the angle of the lens, the greater the DOF. Thus, you have as many options as you have lenses. The trick is to know which lens to use.

This is a critical concept. Suppose you carry four lenses. You come upon a photo opportunity. You size it up. You wait for a feeling to register. You put it into words. You see it in your mind. *Only one camera position and one lens will bring it off.* The picture in your mind (previsualization) makes lens selection relatively easy if you know your lenses. A pro knows exactly what every lens does in terms of image area covered and its DOF limitations and advantages.

You should too. Experience will teach you. *Use only one lens until it becomes your intimate friend and creative helper.*

5. DOF preview button. Most 35mm cameras have a preview button. A well-kept secret! Simply press the button to see what your lens is seeing. At f3.5 you will see a much different picture than at f16. Here's a chance to use your selective vision. See the scene at f16 with everything sharp. See it at f8 where things begin to happen with background and foreground softening (especially foreground). See it at f1.4 for a still different visual experience.

6. Steadiness. You hear some photographers say, "Oh, I can hand-hold a camera at 1/15 sec and be tack sharp." Either they never blow their pictures up larger than 5x7 or they don't know what sharp is. Their attitude is, "If God wanted sharp pictures he would have made cameras with feet."

Tripods, monopods, doorways, walls, car hoods, bean bags, and a lot of gadgets *were made to answer photographers' prayers.*

More on steadiness in *Steady as You Go.*

7. Mirror-up capability. This device, available on some cameras, is the least used of a camera's capabilities. Few believe that there is an ever-so-slight jar when the mirror on an SLR camera slaps up at the time of exposure. It does happen, and you may not realize how many of your photos (especially macro close-ups) have been marred

by this. Many pros use the mirror-up position with the camera on a tripod and a cable release under critical circumstances. They feel they are buying insurance.

Sharpness is a virtue. But beyond that, you have *sharp/soft creative control* when you know the factors that affect focus.

Dealing with Motion

Just as you rely on illusion to represent depth, you also rely on illusion *to represent motion.*

Depending upon your equipment, skill, and intent, you have a multitude of creative options in dealing with a moving object or a stationary object you want to make appear to be in motion.

Whether you choose to freeze action or blur it, keep in mind that shutter speed is affected by the speed of the object's movement, its direction (a subject crossing in front of your lens has more apparent velocity than one approaching you), and your distance from the subject.

What we know about the real world has a lot to do with what we understand about a picture. We may see a speedboat that is frozen in sharp focus by a fast shutter, but the boat's wake tells us it is moving. Similarly, when we see a stop-action shot of a ballplayer sliding into third base we know he was going at full speed.

Creative Options. What are the techniques you can employ to express your personal impressions of movement? Let me count the ways.

• Normal shutters at fast speeds (1/1000-1/2000 sec) can stop action such as sports. Even relatively slow shutter speeds can be effective,

Freezing a peak moment of action presents a dramatic view quite unlike we ever experience with our vision. A fast shutter speed enables you to freeze action, depending upon a number of circumstances.
Photo by David Lissy

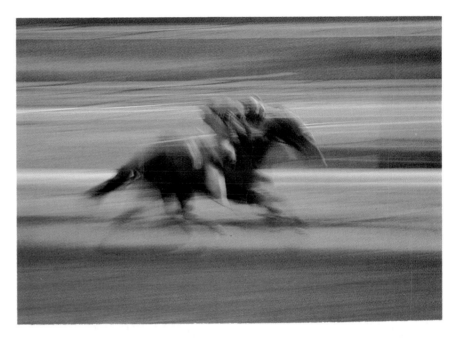

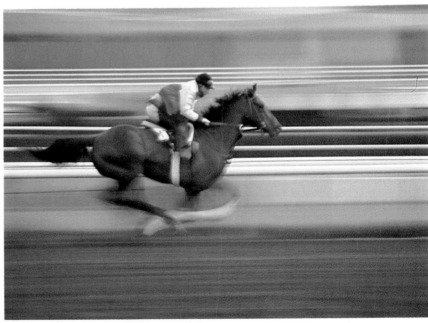

By comparing these two versions of a race horse you can see that you have full control of the final impression.

By controlling shutter and panning speed you can choose an illusion of motion that coincides with the idea you want to convey. Photo by Manny Katz

especially if the subject is caught at the peak of action, as when a pole vaulter reaches the peak of his flight and is about to descend.

• Slow shutter speeds give you control of blurs from slight distortion to impressionistic. To reduce the light striking your film (so you can use a slow shutter) use neutral-density filters or polarizer. For black-and-white film you can slow things down a great deal by combining a polarizing and red filter.

• Pan with the action.

• Pan against the action.

• Zoom in.

• Zoom out.

• Pan and zoom at the same time.

• Double expose on one frame, one shot stopping the action, the other blurring it.

• Double expose slightly out of register for a ghost-like halo (*see R. Hamilton Smith's Electric Tulips, page 25*).

• Do the same with motor drive or auto winder, with more than two action shots on a frame.

• Wave your camera in the air in a random pattern to make a fantasy of night lights.

• Shoot from a moving vehicle. Note how different are your results from the side window as opposed to shots from the front or rear windows.

• Double or multiple exposures can make an object at rest look as if it is moving. The images can go from side to side or from top to bottom.

• Kick your tripod as you release your shutter.

• Crank your tripod up or down when making a long exposure.

• Take two shots of action on a single frame. Let one blur and stop the action of the second shot with flash.

• Time-lapse photography is possible with double exposure. As example, show an oil pump in its "up" position and a second exposure in the "down" position. The first can be a normal

The combination of electronic flash and a continuous light source with long exposure is a highly creative way to portray motion. The flash stops the motion while a slow shutter speed (bulb setting) records a blur. Both are done simultaneously.
Photo by Barbara Boros

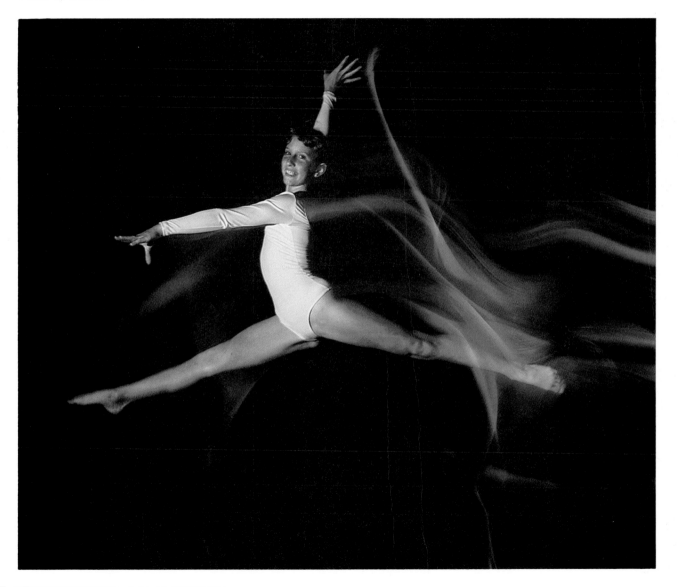

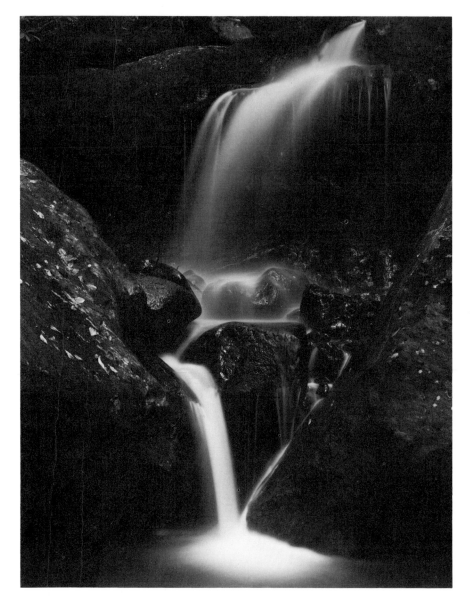

Moving water presents many
creative options. Here Otis Sprow
chose a very slow shutter speed to
exaggerate the water's fluid
quality. A crashing wave may
require a different interpretation
and hence a different relative
shutter speed. The choice is yours!
"Falls and Light" by Otis Sprow

exposure and the second a ghost image. Use a tripod to assure that both images are in register.

• Another example is a photo of a building with the exterior details of a daylight shot and also with nighttime interior lighting. Take two exposures on one frame, perhaps an hour apart at the end of the day, with your tripod anchored in position.

• Prisms are available that give an impression of movement.

• Extremely slow shutter speeds can make Times Square at noon look like a ghost town. If you can slow your shutter to about several seconds, things that move in and out of your picture will not register on your film. Only stationary objects such as buildings will show up in the photo.

• Stroboscopic photos of continuous action (such as a golf swing from start to finish) are possible with a stroboscopic light.

• Move your paper while printing.

Perhaps I have missed a few! Polish your act with any one or more of these techniques by practicing them and keeping notes.

Isn't it amazing how many different creative tools are bound up in one little box with a lens! But without your creative input, one camera does as much or as little as another. *Knowing your equipment and how to use it is a pro difference.*

Understanding Your Meter

Now we get down to *who runs the show;* who determines the emotional impact of your pictures, the accuracy of your message?

Will it be you or your meter?

My guess is that, like most photographers who have not yet discovered the pro difference, *you do pretty much what your meter tells you to do!*

The light-gathering patterns of various meters differ in their quest of average gray. Here are a few examples. It is important to know your equipment's idiosyncrasies and how to work with them for the results you want.

Here's some good news and some bad news.

The good news is that *you* have a brain to free yourself from the bounds of your meter. You are a discerning person with unique taste, sensibilities, and perception. Your meter has none of the above. You'd think it would be "no contest."

Meter Fixation. The bad news is that *your meter has a fixation* that can overpower your brain and individuality. And it will unless you recognize it as a foe and face it head on. (I mean *head* on.)

You know about your brain; let me tell you about your meter's fixation. *It thrives on middle-gray*, reducing all it sees to middle-gray (Zone V). And if you follow its instructions it will skew all your colors in that direction.

If you measure the light reflectance of a very light-colored object or scene, your meter will have you render it gray. The same holds true for a dark-colored object.

A meter — any meter — receives light from reflective surfaces (except for an incident meter, which measures ambient light), calculating the quantity of light according to its own unique light-collecting pattern. It tells you how to set your f/stop and shutter speeds *so that the object or scene will register on film as an average of the light collected.* That average is middle-gray.

It will be middle-gray whether you want an average or not or whether you want a gray-white object or a gray-black object.

The Zone System. *This problem is so important that Ansel Adams and others developed a complex system to overcome the meter's fixation.* It's called the *Zone System*, and while you may not use it (it has tremendous application for black-and-white photography, limited for color), you should understand it.

An exponent of the zone system would know to open his aperture or reduce his shutter speed when metering a white wall so the wall will be rendered as white. He would know to close several

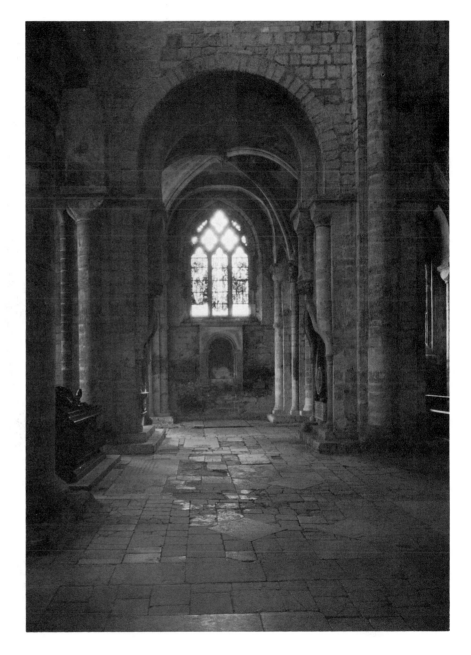

The actual scene in this cathedral was bright and complicated by overpowering light entering the center window. Bruce Barnbaum controlled that intense light when printing, using a flashing technique. To express the mood this room evoked in him, Bruce printed it dark.
"In the North Transept, Winchester Cathedral" by Bruce Barnbaum

stops to correctly record a dark tone.

A more practical example: The muddy Mississippi River is a tan color around noon on a sunny day, about Zone VI. If you follow your meter the river will be recorded as a darker brown, Zone V. Photographers who understand the zone system, even a little, will know to open one stop to reproduce the river's color with fidelity.

More Meter Problems. *The meter doesn't know or care what your selective vision sees in your viewfinder.* It averages it all. Let's say you are photographing a skier who occupies less than half of the frame. The meter sees all that snow and says, "Oh, lots of light. I'll tell the turkey on the other end of the camera to close down." Which you do, underexposing the skier. The degree of underexposure *varies with the light-gathering pattern of your particular meter.*

That's the point. *You have to understand your meter.* Some are center weighted, giving more weight in their calculations to light falling on the center of the meter. Some meters are bottom weighted, some bottom/center, some claim to average, some combine a spot meter. One meter pattern will give a slightly different reading from another. So you must know your own meter because that slight difference can be a win/lose difference.

You must think of your meter and camera and lenses as a *system* that should be checked at least yearly by a qualified camera-repair service. Your f/stop or shutter speeds may be off.

With shutter speed off one-half stop and f/stop off one-half in the same direction, your exposure will be incorrect by a *full stop.* When you consider that a stop doubles the amount of light, or reduces it by half, even a slight deviation from accuracy can be critical.

Some lenses, especially telephotos, may give a reading different from that of a normal lens. *Only testing and fine-tuning your system will assure you accurate metering.*

So consider your meter reading only as a BASE POINT. From it you should be able to 1) render tones exactly as they are in the real world — *accurately* and 2) exactly as you want them to be — *expressively.* (*See Exposure.*)

Fine-tune Your Meter

Because you may be deviating from your meter's instructions (to control either accurate or expressive exposure), you must know how your meter behaves under different conditions. When you know this, you will be able to fine-tune your meter.

Nothing is more important. It makes no difference how well you see photographically, what feelings you have, or what idea you want to communicate; if your exposures are off, your pictures will fail to convey your idea or emotions.

Test for Overall Accuracy. As I stated, the sole function of your meter is to determine f/stop and shutter settings to produce a middle-gray.

Are you sure your meter is functioning accurately?

Test it by photographing a Kodak Gray Card following the simple instructions included with the card. Use transparency film, which has less latitude than color negative or black-and-white film, hence a more precise measurement. Use any light — sun, shade, indoor lighting — but be consistent in all your tests.

For your first shot set your ISO (formerly called ASA) as indicated, for instance 64 with Kodachrome 64 or Ektachrome 64. For successive frames change your ISO to 50, 40, then 25 (you are overexposing). Then do another series at ISO 80, 100, and 125 (underexposing). Be sure to *carefully record each shot* on paper or

you'll negate the test.

When you get your slides back, mark the slide mounts with the ISOs as recorded. If possible, project the slides or view them on a color-balanced light box. If you have neither, be careful what lighting you use to view the slides because you might get misleading information. (Daylight is better than a light bulb.)

Compare your slides with the Gray Card. One slide will be the winner. *That is your EI (exposure index) for the lens used in the test.* In other words, for that lens you may find it necessary to set your ISO dial at 50 or 80 for ISO 64 film. If you are off more than that have your camera checked; something is drastically wrong.

Test all your lenses in this manner. You may find that their EIs differ, especially for your longer lenses.

An added caution: If you wear glasses be sure to use an eyecup. Without one, strong light can enter your viewfinder from behind and influence your meter!

Color Test. Here is a critical test for color film. More than anything else *you want color to faithfully register detail in highlight areas* (Zone VII).

Select as a subject a white, textured material such as a stucco or painted brick wall, sweater, etc. Sidelighting will be helpful. Be sure to fill your viewfinder with the object. Take a meter reading and *open two stops.*

Again change your ISO settings as you did in the Gray Card test.

View your slides from the viewpoint of seeing *detail in the highlights.* The ISO that best renders Zone VII is the one you want as your EI. This should be the same EI as you found with the prior test. If not, they should be very close. *Go with the EI you determined with the Zone VII test for color film.* Use this EI for black-and-white film.

Peripheral Influence Test. It is essential that you know the idiosyncrasies of your meter, particularly when *light or dark fields surround an object in your viewfinder.*

To conduct the Peripheral Influence Test, find a scene or set one up on a tabletop. Place a light-colored object (a vase or plate), against a background that is a deep color. Get a sheet of colored board from an art supply store — dark-gray, deep-red, or dark-blue.

The object must occupy a little *less than one-half* of the area. This represents a scene in which you cannot meter the subject itself separately.

Meter the entire scene, being sure it fills your viewfinder and that your shadow doesn't fall on the scene while you are metering.

With slide film make an exposure according to the meter reading, *using your newly established EI* (if you had to make an adjustment from the standard). Then make additional exposures ½, 1, 1½, and 2 stops over. Then make four underexposures using the same increments.

It is imperative that you *record every frame*, and when you get your slides back transfer that information onto the slide mounts.

Now repeat the test with a dark object on a light background. (Buy pastel shades of board.)

Then meter both backgrounds and photograph them alone — as the meter tells you.

First look at your slides of the backgrounds alone. Both slides shot according to the meter reading will be closer to gray in tonal value.

What does that tell you about your meter? If you plan to photograph a very light object, how many stops will you have to open? How many stops must you close when photographing a very dark object?

Open for white? Close for black?

Many people find this concept hard to understand. Look at it as an artist does. If he wants to lighten a color he adds white. To

darken a color he adds black (or another color that has the same effect). *In photography you add or subtract light.* It's that simple!

Now look at the slides with objects against backgrounds of opposite colors. What are your observations about peripheral influence on your meter as it relates to over- or underexposing the main subject? What meter adjustments would you make if you were photographing a skier on a snowy mountain? A golden aspen in the sun with the background in deep shade? A portrait against a dark backdrop, a light backdrop? What if your center of interest is light against a dark field? Dark against a light field?

Answer these questions by photographing similar situations. You will become familiar with your camera as a system. Don't forget to test it with each of your lenses.

You should be able to answer the following two questions automatically, just as you will when you actually encounter such situations.

1. A light object against a larger *dark* background requires that I ☐ open, ☐ close my aperture (or adjust my shutter accordingly)?

2. A dark object on a larger *light* background requires that I ☐ open, ☐ close my aperture (or adjust my shutter accordingly)?

It all comes down to this: *Will you lead or be led?* Will you be slave to your meter's stubborn middle-gray or *will you control the feeling and spirit of your pictures?*

Exposure —
Accurate

Now that you are on a first-name basis with your camera system and your meter knows who is boss, every scene, every object of average tone range will be rendered accurately.

Freeman Patterson viewed this bench from several angles until he found the light striking it in a manner that brought out lines and shapes. He chose to render the bench accurately while shadows darkened. The light tones of the bench clearly delineate its structure.
Photo by Freeman Patterson

Another example of the Zone System in action. In black-and-white photography you control exposure and development to preserve both highlights and shadows. Without knowledge of the Zone System Ray McSavaney would never have been able to record these strongly contrasting images. Technical skills enhance your artistic sense.
Photo by Ray McSavaney

But, alas, everything is not average in tone.

Even average scenes can be messed up by undesirable influences, such as too much sky. And what if you want to photograph your red setter running through a field of light-yellow daisies? This poses another common problem.

Back to the sky. Scenics will often be underexposed if too much bright sky is in your picture. When the sky fills much of your composition, point your camera down so that the sky occupies *no more than one-quarter of your frame*. Meter, and then recompose your picture, *but use the reading that excluded much of the sky.*

Now your dog. Take a reading directly on him (chances are he is Zone V). What adjustment would you make if your dog were white? Black? Use the meter reading you took close up. You are then assured that your dog's color will be exposed correctly. The daisies, however, may suffer. *There is always that compromise in color photography!* In black-and-white you can compensate.

Had you metered the whole scene, the daisies, which fill most of the frame, would have told your meter there is plenty of light, *causing you to close down,* recording your dog as very dark and with little detail.

You can verify this by giving your meter the Peripheral Influence Test. *(See Fine-Tune Your Meter.)*

Suppose a buffalo is your main subject. You cannot whistle the buffalo to you for a meter reading, as you can your dog. (An incident meter is helpful in situations like this, as is a spot meter, but I am confining my discussion to your camera's TTL meter.)

You could switch to a telephoto lens to take a reading on the buffalo, providing you have tested to find the true EI (exposure index) for that lens, and then switch back to whatever lens you were using.

Or you can meter anything at hand that approaches middle-gray, such as an expanse of grass, an asphalt road, or your hand (and open one stop). *Be sure your substitute target is in the same light*

as your subject.

Or follow the instructions included with your film. It is surprising how accurate these instructions are!

Or you can meter a Kodak Gray Card.

What, carry a Gray Card in the field?

I do. A 5 inch square chunk is sufficient, larger is better.

More Gray Card Uses. "Bert," you say, "you must be hooked on the Gray Card."

Yes, I am whenever critical exposure is required and accurate camera metering is not possible.

For instance, you get a paying assignment to photograph a number of pictures out of books and magazines for a slide presentation, or to copy someone's paintings. If you meter each picture separately you will find that a moonlight scene becomes a daytime scene. Or a polar bear becomes a gray bear. We're back to square one where the meter wants you to shoot that nighttime scene with more light and the icy scene with less light so both will be gray.

The way to handle this project is to *take one meter reading* of a Gray Card. Once you make your setting, *do not change* for each picture, regardless of what your meter says.

There are exceptions: When using a Gray card for a dark subject, open one-half to one stop. For a light subject, close one-half to one stop. Only practice will tell you whether one-half or one. For everything else, *stay with your original settings.*

Caution: Always meter a Gray Card in the same light as your subject.

When you buy a set of Gray Cards you will get printed instructions for determining correct exposure for frontlighted, sidelighted, and backlighted scenes. The instructions include adjusting for light ratios, checking light distribution, and controlling background rendering.

When I do product shots or still life, I find the only way to meter accurately is to place a Gray Card in the setup, and meter on it. It's also a good idea when shooting the first frame of a color portrait session to include a Gray Card. This gives the lab a specific area to analyze and assures good skin tones.

Metering for Sidelighting. Sidelighting brings out texture, produces greater depth and three-dimensional volume, and, because it produces shadows, has greater contrast than frontlighting.

A box with frontlighting has no depth at all. On the other hand, if you light it from the side and high, the top will be light, one side becomes light gray, and the third visible side is dark gray. A shadow appears to further state *this is a box you can put things into.*

Metering has to be done judiciously when an object is partially in bright light and partially in deep shade. If it is a building, do you want to retain detail in the highlighted area or in the shaded portion? If the contrast between the areas is four stops (16:1 light ratio) you will have to make that choice. In color you will probably meter the highlights; in black-and-white, the shadows.

If the difference is less than two stops, meter both areas and strike an average. (For light ratios in portraiture, *see People Pictures.*)

Exponents of the zone system know you can expose black-and-white film for the shadows and develop for the highlights to hold both shadows and highlights in the print.

Metering for Backlighting. A light source behind your subject gives you even more depth than does sidelighting. When you can, use reflectors to cast light back onto the subject giving you perfect control for a box or for a portrait. Backlighting also provides more distinct separation of the subject from the background. The halo or rim light that can be created by backlighting is unique and a real zinger.

Backlighting is difficult to meter. The most accurate way is to move in close to your subject and meter directly on it. If that is not possible, meter the scene and open about two stops (rule of thumb). Don't forget when metering up close to take into account the tone you want to render. Keep in mind that your meter reading will render a middle-gray tone even if you want skin color.

Metering Small Objects. You can eliminate the problem of accurately metering, small objects by *moving forward and filling your frame with the object.*

Take portraits, for example. Because skin tones are critical, meter a face full frame. (Then don't forget to adjust for light or dark skin.)

If you cannot get close, use *the old Gray Card*, being sure it is in the same light as your subject.

Or use an incident meter if you have one.

Or use a substitute for a Gray Card — a patch of grass or gray road surface.

One more thing to consider: *bracketing.*

This is a controversial subject. *You should gain the skill and confidence to make the exposure you want every time.* Well, almost every time. But what if you are in doubt? Or the moment is so precious that you cannot take a chance? Or you want an extra picture for possible sale? Or you want a different mood?

Then bracket: *Shoot additional plus and minus exposures.* There is this possible bonus: One of your extra exposures may be better than your original, *may have more emotional impact!*

For commercial work bracketing is wise because the technician responsible for color separations for four-color printing may prefer a transparency that is one-half to one stop over- or underexposed.

With practice, constant review of your work, and KEEPING GOOD RECORDS of your exposures, *you should eventually have very few bad exposures.* They should be *right on the button.* Accurate, rich colors. Excellent tonal range. Sparkling colors will

sparkle. Subdued colors will be quiet. Within film limitations your highlights will have detail, *if you so choose.* Your shadows will have detail *if you so choose.*

The point is *you* choose, *you* control.

Exposure — Expressive

I posed the question earlier in this book: why two photographers can photograph the same scene side by side with relatively the same equipment and one will produce winners, while the other produces pictures that never get a second glance.

Answering that question is the main quest of this book.

Let me restate one of the basic tenets of this book: In any photographic situation, YOU HAVE A CHOICE. You have the option to render your image 1) *accurately,* with fidelity, exactly as you find it; or 2) *expressively,* as you feel it. This is an art decision.

Whatever you do thereafter to implement this decision is a matter of craft — selecting the most appropriate technique.

Expressive exposure in color photography revolves around two decisions: 1) Highlight vs. shadow, and 2) Film selection.

Highlight vs. Shadow. The reason diffused light, as on an overcast day, is so desirable for color photography is that no highlight/shadow decision need be made.

However, when you are working under a special light condition, as on a sunny day, you must decide:

Do I want to emphasize or preserve highlight detail *at the risk of losing shadow detail?*

Or do I want to preserve shadow detail *at the risk of washing out highlights?*

Those are the two choices for color film with specular light.

On the other hand, with black-and-white film, you can preserve the fidelity of both highlights and shadows to a great extent, by judicious exposure and manipulation in developing.

What really is so very different, so expressive, about the highlight/shadow choice?

Let's explore a scene. Visualize a color picture of a sea crashing against rocks at noon on a sunny day. Here are your options:

Normal (average) *exposure* probably will render good detail in the body of the wave and in much of the rocks. Everything that is quite white — the wave's crest — and everything that is quite dark — the rocks in shadow — will lose detail. Washed-out whites, blacks without detail.

Overexposure will result in more highlights being washed out, *but the rocks will retain detail.* They become sturdy, composite structures, alive with rivulets flowing back into the sea. Seaweeds abound, following the pull of the previous wave.

Underexposure causes the wave's crest to become fragmented, flying in a thousand directions, a single unit of enormous force. *Highlights retain detail* even though they no longer are pure white. But they appear so, by contrast, because the sky and the rocks have become darker. Rivulets lose their identity but their highlights sparkle. Rocks become solid masses without detail.

Which expresses your feeling, preserving the detail in the rocks, or in the highlights of the wave? (With B&W film using the Zone System you preserve both.)

When you are working with a smaller subject you can forego a highlight/shadow decision by using a fill light or reflector to reduce the light ratio and preserve both highlights and shadow detail. An example is a still life flower or portrait.

In color photography you will most often go for detail in the highlights. Be sure your EI has been adjusted so you know exactly what you are doing. *(See Fine-Tune Your Meter.)*

Expressive photography results from expressive exposure, which in turn relies on previsualization — dictated by how you feel about your subject, what you want to communicate.

How would you photograph this scene? Pretend that you are there. Think before you shoot. Previsualize and then make this decision: Photograph the scene as you see it (accurate exposure) with detail in the buildings of the Taj Mahal, or as you feel it (expressive exposure) perhaps with the buildings in shilhouette and the sunset deeper in color. Other creative options?

Photo by Bob Citron

The exposure for this photo had to be on the button to render both highlights and shadow details. It was so accurate that no negative manipulation was required and it is a straight print.
"King's College Cathedral, Cambridge" by Bruce Barnbaum

Sometimes your position in relation to the light source will give you an opportunity for expressive exposure. Here backlighting with leaves rimmed in frost could be captured only by careful, interpretive metering.

Notice how graphic the design of this photo is and the strong separation of the subject from its background. How would more exposure give a different expressiveness? Less exposure? Photo by Freeman Patterson

Expressive exposure was gained in this instance by extended exposure and compensating development. Notice the ghostly aura of the light, adding mystery to a commonplace scene. Only with technical skills can the artist make so personal a statement. "Beneath Santa Monica Pier" by Bruce Barnbaum

Expressive exposure can often be accomplished through special manipulation of the negative. Bruce Barnbaum wanted light to envelop these trees. By overexposing considerably and extending development extensively with a dilute developer, Bruce was able to communicate the feelings he previsualized, with muted highlights and good separation of tonal values.
Photo by Bruce Barnbaum

Electronic flash, used with extraordinary imagination, can lead to extraordinarily expressive exposure. Royce Bair used multiple flash and long exposure (note the star trails). With this not-your-everyday technique Royce gave stunning color and detail to the natural bridge, yet retained the integrity of a night scene. Photo by Royce Bair

Film
Selection

The other decision in expressive photography is which film to use. Here are your choices:

1. *Color interpretation.* Does the picture call for brilliant rendering or muted tones? Most photographers try to capture the impact of color with films that transmit the color's brilliance. A rare few photographers are more sensitive to nature's quiet colors. They use films that experience has taught them reproduce muted tones.

2. *Color bias.* Each film is biased toward red, blue, or another color, especially for very long exposures.

3. *Grain structure.* Your choice here is dictated by enlargement considerations. Slower speed films have a finer grain, assuring better enlargements.

4. *Film speed.* Slow, medium, or fast? Your choice is dictated by the quantity of light and the movement of the subject for a sharp image.

5. *DOF.* While depth of field is not a film factor, a requirement of deep DOF may influence a decision on film speed. The faster the film, the greater DOF potential.

6. *Type of film.* Should you choose transparency (slide) or the print film? Pictures intended primarily for color prints should be made on negative film: Koda*color,* Ekta*color.*

If the final use is for commercial purposes such as magazines, brochures, rental (and color prints too), you *must* use transparency film, such as Koda*chrome* or Ekta*chrome.* Transparency film is used most by professionals.

Get to know all the types of film so that you select the film to express what you want in a photo.

Film selection, especially color film, is important in expressive photography. Film speed, color bias, grain structure, and other properties exercise great influence over the final result. Freeman Patterson is a great exponent of careful film selection, especially for capturing more subtle colors that evoke a mood.

Experiment with a variety of films to discover for yourself that there is a right film for a given situation.
Photo by Freeman Patterson

Freeman Patterson suggests that, after your last frame on a roll, change film and shoot the same scene. You will then have a side by side comparison of the emotional difference.

You can shoot a roll and learn the expressive difference of exposure by bracketing and recording your exposures. Then, before your very eyes, *you will see what expressive control you have.* (*See Shoot A Roll—Learn A Creative Control.*)

Steady as You Go

Experienced photographers learn what we used to call "field expediency" in the Army. You see them steadying their cameras against door jambs, on car hoods, on railings, etc. You also see them propping their backs against walls, sitting and bracing their elbows on their knees, or on their bellies supporting their cameras with their elbows. *Any way is a good way if it steadies your camera!*

If you hand-hold your camera, take these admonitions to heart.

1. *Your slowest hand-held shutter speed should approximate your lens size.* For a 50mm lens your shutter speed should be about 1/60 second. For 105mm to 135mm lens, 1/125; for 200mm lens, 1/250.

You can see how limited you are when holding a lens, especially a long one (which is usually heavy to boot). With those faster shutter speeds you have to open your aperture, reducing your DOF, resulting in loss of creative control.

2. If you have trouble holding your camera steady, *double the speeds* in the rule above. For example, 1/60 becomes 1/125; 1/250 becomes 1/500.

At these speeds you are probably operating with fully open

aperture and your DOF is reduced even more. This compounds the problem of sharpness because, as I have said, the larger the aperture, the less the apparent sharpness. Shooting wide-open your focus must be 100 percent on target or you will probably end up with mush, which wastes your time and film and maybe a once-in-a-lifetime photo opportunity.

In addition, you have no creative depth-of-field options.

The Tripod. If you are satisfied with *relatively sharp* pictures some of the time, and *out-of-focus images* occasionally, don't invest in a tripod.

For simply taking pictures, a tripod is a nuisance. But *for making pictures with the intent of producing great pictures,* a tripod is an indispensable tool. Here's why.

1. *There is no comparison in sharpness* between an image shot hand-held at anything but the fastest shutter speeds and one taken with camera on tripod. Until you use a tripod and see your images under high magnification, you will never appreciate the difference.

An average-quality lens on a tripod-mounted camera will give you *quality compared with the finest lens when hand-held.*

2. *Most hand-held shots will not stand a large blowup.* For wall decor the first three requirements are sharp, sharp, sharp.

3. *Under low-light conditions* a tripod will enable you to *take shots that are impossible hand-held.*

4. With a tripod you can use your smallest aperture for *maximum depth of field.*

5. A tripod is *essential for close-up work, copying,* etc. Don't even think of close-up work without a tripod.

6. If you plan to do *still life, product shots, or any commercial work,* you can rarely operate without a tripod.

7. For ultimate sharpness a tripod enables you to shoot in the *mirror-up position.* For extreme close-ups this is a necessity *(See Mirror-Up in Fine-Tuned Focus).*

8. A tripod *aids you in composing* more carefully and in controlling double exposures, multiple images, and special-effect filters.

9. When working with a model *a tripod affords you eye contact* instead of having a camera in front of your face.

10. Psychologically, a tripod causes you to *think out your pictures* rather than point and shoot.

11. *A tripod gives you confidence!*

This is not to say that you should always shoot with a tripod. Only use it when circumstances require one and your intent on making great images is serious.

But once you become used to thinking a picture through with a tripod, this attitude will carry over when a tripod is not necessary.

Sure, a tripod is a pain to carry, but it is much easier if you make a sling out of an old camera strap and carry it over your shoulder.

There will be times it is impossible to transport a tripod to your destination or carry it when you get there. A substitute is a *monopod.* While it does not do all that a tripod does, a monopod is much superior to no support at all. It can save the day, especially for sports!

Be sure to get a monopod that is easy to extend and collapse. If you cannot purchase one with a ball socket head, buy that accessory separately.

Caution: Don't buy a cheap tripod. If you do, you will soon find you need a better one. A tripod need not be heavy — just sturdy enough for the size and weight of your camera. Test one by setting it up and putting your hands on the platform and leaning on it. If it collapses or wobbles, try a better one. Compare a number of brands and models to find the features that satisfy your needs.

No question tripods are a burden to carry; but if you can and when you can, use one. *It's a pro difference.*

Shoot a Roll —
Learn A Creative Control

This book leaves a lot of questions unanswered on purpose. I do not tell you what shutter setting will stop a wave, or what aperture for selective focus, or what film has what color bias.

I do not answer these questions because *you must answer them for yourself, with your equipment.* You learn in the process.

There is an old saying: *"Give a man a fish and you feed him for a day. Teach him how to fish and you feed him for life."*

I want you to learn by doing, by answering your own questions, solving your own problems. That's learning the best way possible.

The way to learn your camera's creative controls begins with shooting one roll of film! *One roll = one technique learned.* Two rolls and you are on your way to mastering it.

List the controls you want to master and write down every aspect that is in question. (This is a good time to refer back to the *Creativity Strength and Weakness Checklist.*) Put your questions in order with the most basic first, because each technique builds on another. *This is how your talent evolves!*

Set up a situation to learn *one* control and begin to shoot. Record every shot in a notebook — film, aperture, shutter speed, filter, lighting, everything special about the picture. Use any type of film, but slides are preferred because you get results faster, at less expense. And when projected what you have done is more obvious.

Look at your photos and compare the results with your notes. Did you achieve what you set out to? Look at your worst picture and your best. Compare them. The truth will be evident!

Voilà! *You have learned one control!*

To *master* the technique you must practice, practice, practice.

Section 5
Special Situations

Two specialized areas that photographers are most interested in, and which require special techniques, are People Pictures and Close-Ups.

For portraiture, basic lighting patterns have been used for decades, and little else has changed during that period. The newer devices are electronic flash, umbrellas, and soft-boxes for diffusion.

Macro lenses, improved optics, and close-up accessories have radically changed close-up photography. They have opened the fantasy world of ultra close-ups to the average photographer.

I urge you to study the numerous excellent books on these subjects. However, I have included chapters on these subjects to cover the essential basics. They are designed to get you started toward a high level of satisfaction, providing you practice what I preach.

People Pictures

Ideally, what should be the standard for formal portraits (as opposed to candids)? Not what is the standard today, *but what should it be?*

In evaluating all art forms, one looks to the source, to long-established principles of art. What better source than the great painting masters and their heirs?

Within the context of producing likenesses, the masters' purpose was to portray character, and at times to tell a story about

It is from portraits like Rembrandt's "Portrait of a Scholar," 1631, and similar works that we inherit an understanding of the guiding principles of formal portraiture. A hallmark of these early — and still prevailing — standards is consideration of dress, accessories or personal accoutrements of the subject that tell a story about the subject's life, character and accomplishments.

their subjects.

How did they accomplish this?

The masters sought studios that opened to the north light for soft, broad, diffused lighting that created subtle tone gradations. This aided them in rendering the human head not as a flat circle but as a sphere — chiaroscuro.

Lighting variations abound. Rembrandt, for instance, used all types of lighting patterns (butterfly, broad, etc.), as well as what we understand today to be "Rembrandt" lighting.

Strong highlights are generally seen on foreheads and cheeks. Men's faces often are half in shadow, ranging from slight to very deep. Women and children less so.

Most of their subjects' eyes are off center on the canvas, above center, and generally facing into the picture. As often as not the eyes are directed away from the painter.

Subjects were seated at pianos, writing tables, in kitchens. Often they were posed at work or trade, and symbolic props such as writing and musical instruments or swords were used.
When hands were included they served a purpose, such as holding something or gesturing, and were carefully considered as part of the overall design.

Most heads were posed almost straight on to two-thirds frontal position; very few silhouettes were used. Shoulders were most always straight on to about 90 percent sideways.

Rarely if ever did the subjects show a broad smile! That is not to say that a smile detracts from dignity, but a smile is certainly forced in a formal portrait situation. Above all they were concerned with the dignity of the individual, no matter what his station in life.

There seemed to be no rule for cropping. Some heads fill the canvas, while others show heads and shoulders, and still others include about two-thirds of the figure.

Character was also revealed by dress that suited the subject's office (aristocracy, church, trade, profession). Except for royalty, clothing was often subdued to emphasize the head.

While there is no question that subjects posed for long sessions and often over a long period of time, in the main they look comfortable, as if they fit into the environment. In many cases, this was because the subjects were in their own homes.

The masters left us a legacy that has guided artists for centuries: *a standard for formal portraiture.* We need not lock ourselves into blindly following them. But, within the more limiting bounds of

photography, we should each find our own way, always *judging our own work by these art principles that are enduring and endearing.*

Portraits

In the following I include only what I believe to be *the building blocks of good portraiture.* I urge you to study books and magazine articles on the subject and attend classes and workshops.

Study is one thing, learning is another. I strongly recommend that you practice the principles of good portraiture. At first use a mannequin head (*see Free Portrait Model*) and then use live models.

There are two major approaches to portraiture:

1. Flattering physical likeness.
2. Character rendition.

The Flattering Portrait. Portraits that flatter are the principal goal of most photographers because that is the principal desire of the subject.

If the subject is attractive the task is relatively simple, but by no means a cinch. People who cannot be photographed poorly are rare.

So in most cases we must concentrate on *accentuating the subject's positive* features and *minimizing the negatives.* It takes a well-trained eye to spot the best feature, and skill to emphasize that feature in a picture.

It takes even more skill to minimize negative features. This calls upon "corrective techniques." You can read about these in a number of books, one of the best being Kodak's *Professional Portrait Techniques.* Here are a few corrective techniques from that book.

Difficulty	Suggested Treatment
Wrinkled face	Use diffused lighting
	Lower main light
	Use three-quarter pose
Double chin	Raise main light
	Tilt chin upward
	Use high camera position
Baldness	Lower camera position
	Screen to shield head
	Use no hair light
	Blend top of head with background tone

You can see that *to emphasize* a feature you would do much the *opposite* of what this chart tells you — making it a valuable chart indeed. For instance, if you want to emphasize wrinkles for a theatrical shot or to show age or character, you should use specular light rather than diffused and a more straight-on pose. But rather than raising the main light you would move it to the side for cross-lighting to emphasize the wrinkles.

Portrait techniques, whether emphatic or corrective, combine *appropriate lighting, posing, and camera angles.* Makeup and costuming are other factors that help to flatter.

Character Revelation. Now we are in rarefied atmosphere. This is a higher order of portraiture, a realm occupied by too few photographers.

Two who are recognized as the best are Arnold Newman and Jousuf Karsh. They are world-renowned because of their ability to *transcend flattery and go to the core of the person.*

How do they do it?

They take time to *know their subjects.* They read their subjects'
books, articles, speeches, listen to their music, analyze their art.
They spend as much time as possible with their subjects.
Sometimes it is only a few minutes but it might also be hours or
even days. Through sensitivity and experience they are able to gain
insight into their subjects in a short, relaxed conversation. They get
to know them psychologically as well as physically.

Karsh is more concerned with his subject's physical
characteristics, Newman more with symbols and environment.
One of Newman's most memorable photographs is of the composer
Stravinsky at a piano with the raised piano top looking like a giant
musical note. (*See page 163.*)

Some of *the most character-revealing portraits, to my mind, are
being done in the world of photojournalism,* as evidenced by some
of the photos you see in better newspapers and news magazines.

Flattery vs. Character Rendition. While there will never cease to
be a vast market for flattering portraiture, in my opinion *the future
belongs to the photographer who reveals his subject's character.*

As our society works its way through this period of materialism
and pretense and returns to its foundation of high human values,
the market for insightful portraits will expand.

We all have multiple roles in life. Parent and teacher. Spouse and
lover. Boss and bossed. Hard worker and sports fan. We are a
different person at a bridge game than we are at a bar. We may be a
lion at a family meeting, a mouse at a company or community
meeting; a benevolent soul at a scout meeting, a killer at a football
game or boxing match.

Which "person" do we photograph?

Look at it this way. The subject is an architect. His daily
occupation and lifelong interest is designing and building, and how
people live and work. He is a loving husband and adoring father.
His natural environment is with his family and close friends, and

Informal portraiture is a logical extension of traditional portraiture and encompasses many of the age-old principles of character rendition. Imagine the misleading and false impression if this man had been photographed in a studio with suit and tie!
Photo by Martin Brown

This portrait of Stravinsky,
considered by many as one of the
most important of contemporary
portraits, epitomizes symbolism
and simplicity with exquisite
attention to design.
Photo by Arnold Newman
© Arnold Newman

at his drawing board at home or in the office.

He half-heartedly goes to a photo studio at his wife's urging and is unprepared to relax before a camera. (Who is?) He is posed three-quarter with a main light, fill light, hair light, background light. Tie straight. A smile. Eyes to camera.

Everyone likes the final picture selection. It is enlarged, canvas-textured, and expensively framed. A successful photographic episode, *like thousands of others.*

This man in the frame, is he the jolly, playful father? The warm, loving husband? The intense designer of buildings? *Is there anything in this picture that even hints of who or what this particular, unique singular man is?*

How would Arnold Newman have photographed him? What symbols would he have used, what clothes, what pose? *Where would he have photographed this unique individual?*

I think the trend will be away from studios and into the subject's environment, with symbols that differentiate and individualize the subject. Then, in the subject's own warm and secure environment, *a smile becomes a smile.*

In recent years this type of picture has come to be known as the *environmental portrait.*

Some photographers can get their subjects to relax in a studio through developing rapport. But without a warm and inviting atmosphere how can the subject relax and overcome his "camera face"? Except for children who do not appreciate the gravity of capturing "this historical moment in time," people do put on a camera face. It is usually not possible to avoid that instant of self-consciousness that coincides with the instant the shutter is released.

I have known a person for many, many years who has the same camera face in almost every picture taken over those years. The moment she suspects that a lens is shifting in her direction she takes on the same frozen smile!

All of which is not to demean the portrait studio or the photographers who operate them. These are the problems a studio operator faces, and often with ungainly, uncooperative subjects who do not pay enough to allow time for character study, barely time to understand the subject's physical attributes and problems.

For many years to come most portraits will still be made in studios. But for the freelancer the merits of environmental portraits should be exciting. *Here is an opportunity to produce satisfying work without the necessity of studio overhead and expensive equipment.*

Enough philosophy. Let's talk about the technical ingredients of good portraiture — in studio, home, office, or meadow.

Technical Standards. Aesthetics are one thing (and should never be overlooked); doing is another. When looking at portraits, and when planning a shoot, *keep these optimum standards in mind:*

1. *The head should be three-dimensional.* This is most easily and reliably achieved through the use of *diffused light.*

2, *Highlights should peak at the higher planes of a face,* at the cheeks, forehead, nose. But they should retain *at least a minimum of skin tone.* (Highlighted areas of moist skin may cause too much reflection. This can be corrected with skin-colored powder.)

This contouring (modeling) is provided by the main (or key) light.

3. *Shadows should be controlled* to emphasize or minimize contours and contrast. The fill light controls the shadows.

4. *Focus should be on the eyes* (use eyelashes as a focal point), with catchlights in both eyes. This is true even if the eyes are not looking into the camera.

5. *Hair should be alive.* This can be achieved by judicious use of light or reflectors to add highlights.

6. *The head should be separated from the background* by light/dark difference, color difference, and/or different planes of focus.

7. *Nothing should draw attention away from the subject.* Clothing, jewelry, props, should be subdued unless it is a fashion shot. *Anything that detracts, subtracts.*

Lighting. Appropriate lighting is the key to successful portraiture.

Window light has always been the artist's ideal. Broad and diffused, it is also the simplest to use. All you need add is a reflector to control the shadows. Move it close and the shadows are almost eliminated. Move it back a short distance and you have slight shadows; move it farther, and you have deep shadows. Simple and absolute shadow control!

Remember this when studying the shadows: They will reproduce darker than they appear to the eye.

Standard studio lighting generally calls for four lights: main, fill, hair, and background. This is complicated and expensive, and it requires lots of room. All of which discourages the average photographer, no matter how serious, from attempting to learn professional portraiture.

I use *one light and two reflectors,* which really means three lights since reflectors are also a light source. My favorite light source is a strobe *through* a translucent umbrella. I don't claim that I achieve all that you can with four or more lights, but with careful placement of the light and reflectors I am satisfied that my work is of professional quality. You see, more important to me than little nuances such as a snooted hair light is *capturing the essence of my subject.* The one-light set-up is sufficient.

Professional quality portraiture is within anyone's means, and very little space is required with a one-light setup.

Conventional portrait lighting calls for a main light about 45 degrees to the side of the subject and above head level. For glamour shots, "butterfly" lighting is most desirable. This is where the main light is in front and above the subject, creating a shadow under the nose that goes half way to the upper lip.

166

Diffusers. It is imperative that you use diffused light, except for theatrical portraits. Diffused light creates that chiaroscuro effect that gives the illusion of three-dimensional volume. It also eliminates harsh highlights. *The closer you place a diffused light and the broader the light source, the softer it is! (See Fact of Light: 3D)*

A number of different materials can be used to diffuse light. There are plastic diffusers made to fit light reflectors of various sizes. However, you can also use a shower curtain, tracing paper, translucent window shade, "glass" cloth, frosted acetate, and any of several materials made by Rosco for the motion picture industry.

Any light source with sufficient intensity can be used: common tungsten light bulbs, quartz, flash or strobe, fluorescent for black-and-white. Remember to use the appropriate color film, or a color-corrective filter will be necessary.

Studio strobes are most often diffused by bouncing them into an umbrella. I find the closest thing to window light can be achieved by aiming my strobe *through* an umbrella of translucent fabric.

The worst portrait light of all is direct flash. However, you can overcome the resulting problems of harsh shadows and red-eye by bouncing light from your flash. Be sure the surface you bounce it off is white and nonglossy. At least, use a flash bracket that elevates the flash or places it at the side of the camera.

Some photographers get good results with a flash off camera (on a lightstand or other support), plus a reflector or second flash used as a fill. This is not too difficult to master and very effective.

Light Ratios. Film can handle a minimal difference between highlights and shadows (film latitude). Too much difference and either the highlights wash out or the shadows go too dark. Here are the ratios:

2:1 ratio. One stop difference is safe but flat and lacks impact (often referred to as 3:1*).

4:1 ratio (two stops). This is considered the best.

8:1 (three stops). This is very dramatic and compels you to choose either highlights or a shadow area for detail. This ratio is often used for strong masculine portraits or theatrical portraits. Careful! Be sure you retain some detail in the highlights.

To determine the ratio of a lighting setup, use your camera meter (a spot meter is better) to measure the reflectance of the highlighted side of the face and then the shadow side.

The ratio between the main and fill light (or reflector) can be controlled in several ways:

1. The main light can be stronger than the fill. If twice as strong the difference will be one stop.

2. The relative positioning of the two lights can change the ratio. If your main light is 4 feet from the subject, the fill light (of equal intensity) can be placed at 5.6 feet — one stop less. Move the fill to 8 feet for an additional stop difference, 11 feet for still another stop. (Do you see the relationship of distance to the f/stop markings on your camera?)

First light the highlight side to your liking and then control the shadow by moving your fill reflector closer or farther from the subject.

Remember that white skin is in Zone VI, whereas your camera meter will record it as Zone V. So, with black & white, be sure to meter the highlight side of the face and *open one stop* or you will create a muddy complexion.

Environmental portraiture lets us see subjects as they relate to their world. This work by Ray McSavaney is a giant step above so-called street photography. Ray sets up as he would for a detailed landscape, bringing to bear his talent as a large-format landscape photographer.
Photo by Ray McSavaney

**Various sources have different ways of stating light ratios. My source is* Photographic Lighting *by Norman Kerr, staff photographer for Eastman Kodak Company.*

Poses. A whole world of posing examples is available to you in newspapers, magazines, books, and advertising materials. Clip the ones you feel you can work with comfortably and make a Posing Guidebook for reference.

Never forget that your subject is part of a composition, *not a bull's eye in a target.* Give consideration to placing your subject's eyes near the Golden Mean.

Props also should be part of the entire composition — never more eye-appealing than your subject. This placement, as well as focus, is important from a composition viewpoint. For instance, a bouquet of flowers close to the camera will add color yet can be out of focus.

Backgrounds. Backgrounds can range from totally unobtrusive to an overpowering glitz. They can be a help or hindrance to a portrait as most any other factor.

You are wise to start simply. I often use a slide-projection screen for head and shoulder portraits. The surface reflects enough light to give good subject/background contrast. Depending on where you place your main light, the screen can also act as a hair or rim light. For a change of pace I hang fabric or colored paper over the screen.

Selection of backgrounds for fashion and glamour challenge the imagination. I have seen everything used from shiny sheet plastic to patterned fabric or wallpaper.

The key is *appropriateness.*

On location you should make very sure the background for your subject is just that — appropriate. A bookcase, for instance, might be just right for a judge, but not so appropriate for a star athlete.

Once selected, you have to make a decision as to how strongly to play the background, or any facet of the environment.

Know beforehand how your background will read by metering it independently.

A background will be several stops darker than the subject,

especially if your light is close to your subject. If you want it of equal value there are several things you can do:

1. Back your lights way off so relatively the same light intensity falls on both your subject and the background.

2. Place your subject closer to the background.

3. Add a light or slave to light your background independently.

Equipment. Any 35mm camera with manual control is suitable for professional quality portraiture (larger format is better). A lens that is longer than your normal lens is most desirable. 80mm to 135mm lenses (for 35mm cameras) are considered best.

You want a diffused light source or a light source you can diffuse, and two white matte finished boards as reflectors. An adequate size is 16x20. There are various easy ways to support the reflectors, but you may want lightweight light stands.

There are almost unlimited accessories available for creating mood and special effects, such as expensive lenses, special-effect filters, vaselinc on your ultraviolct (UV) filter, and black netting.

Many of these provide different ways of diffusing the image to flatter the subject. In black-and-white, the darkroom affords you an opportunity to further this cause. An exceptionally good technique for softening the signs of aging, or giving a glamour model an exceedingly smooth, almost alabaster skin, is *printing through frosted acetate.*

One of the most thorough books on the subject of portraiture is *The Complete Book of Photographing People* by Michael Brusselle.

Techniques for producing pro-quality portraits are as varied as the people in them, whether you use one light to four or more. Select a technique that suits your taste, your equipment, your pocketbook, and your home, patio, or studio. *Practice it until you have it down pat.* Then add the embellishments of props, imaginative backgrounds, individualized poses. This is the sure way to achieve the level of proficiency you are capable of.

Free Portrait Model

How can you practice, practice, practice portrait photography when models are hard to find and expensive to hire?

Buy a mannequin head and cheap wig.

Look for a head that approximates skin color and has eyes, nose, and mouth. It is especially important that it has a nose, because controlling nose shadows is a key to mastering portraiture.

Use it to test lighting patterns, exposure, diffusers, lenses, anything you need to work on.

Do all your learning, make all your mistakes, perfect your style — before you ever place a live subject in front of your lens.

It doesn't cost much, and you don't have to watch your language when you kick over a light or reflector.

Call the display department of your local department store and ask where they buy mannequin heads. They may have an old one to sell or give you. Try a wig shop also for a head and as a source for a wig.

There's no excuse for not practicing. *This model is always available. It doesn't talk back to you, and the price is right!*

This model will be very patient as you sharpen your portrait skills. She's cooperative, the price is right, and the rewards of the practice are high.

Working with Models

Models, actors, even business executives require — desire — direction, whether on stage, or in a television or photo studio.

When working with models for portfolios, publicity pictures, advertising illustrations — and to a degree with portrait subjects — you must make your model understand that *you are the director.* This starts at the beginning of the session when you tell the model the purpose of the shoot, how the picture will be used, what will be accomplished. You state, "I am directing this shoot, but if you have any suggestions as to poses, costume, or so on, let me know."

Remember, you can diplomatically turn away any idea you don't like by stating, "It won't work photographically."

You must be assertive. You may be shy, but that *is not relevant.* If your photos are not acceptable because of weak direction, you have failed as a photographer. You should be able to tell an executive to straighten his tie, or step forward to do it for him, first asking, "May I straighten your tie?"

Treat your model with respect as a lady or gentleman. And don't act in any other way yourself. If you have anything else in mind, get into another business.

Never touch your subject, except with permission. And then only touch with a finger as a way of guiding your model's arm or head.

Never speak to a model in anything but a respectful manner. A male photographer may get a chuckle from a female model with a risqué remark. This encourages him to make more risqué remarks. A model has only two possible responses: 1) more chuckles — trying to be appropriately polite, or 2) telling the photographer to knock it off. Few models use the second response. They grin and bear it, which the photographer reads as encouragement. But you

can be sure you will never see that model again, nor any friend or colleague of that model.

Never, never conduct a private indoor session with an underage model unless a parent or guardian is present. The legal risks are in no way worth it.

For advertising illustrations, you will probably work from a rough drawing. Your job is to pose your model *exactly* as drawn in the layout and to complete the assignment to professional standards. Then you should try some additional ideas that you feel might improve the results. But you must give your client what is asked for, nothing less. *A real pro gives something extra.*

How to Direct. Here is one way to *control the position of your model's head for portraits.* Hold both your hands in front of you in a vertical position about eight inches apart. From where you stand at your camera position, tell your model to pretend that his head is between your hands.

As you tilt your hands, *your model's head will tilt* with them — just as if your hands were actually holding his head.

To *pivot your model's head,* tell him to imagine that your thumb is touching the end of his nose. From your camera position, you hold up your thumb and move it from left to right. The model's head will pivot just as if his nose were resting against your thumb.

Practice this in front of a mirror.

Preparing for a Shoot. It takes years to develop a good number of poses with which you feel comfortable. Here is a way to solve that problem, and the one of costumes too.

Have a preliminary meeting with your model (in person preferably, but you can do it on the phone). Discuss the end use of the pictures and suggest the model clip photos out of magazines that represent what he has in mind for poses. This will also indicate possible costumes and props. The model should bring all

the clips, costumes, and props to the shoot. Thus the posing problem is simplified; just follow the photos.

It is important that your model feel comfortable with a pose. You can ask, "Do you feel at ease with this pose?" If not, drop it.

Rapport. Sometimes a creative spark flares between two personalities. This is ignited by mutual respect between the photographer and the model. This rapport may be the vital ingredient to a successful shoot. You help the cause by complimenting your model and reacting enthusiastically to each shot. Keep the conversation light and upbeat. If your model does not enjoy the session it will not be successful.

Your profits from a "shoot for profit" session will be in direct proportion to how many *different* good shots you take.

Like everything else in life, success comes from practice and experience. Be smart and do as many practice shoots as possible, using family, friends, and neighbors — people you feel comfortable with.

You will be amazed how skilled you will get simply by working at it!

Close-up
Fantasy World

Close, closer, still closer. Journey into a world of lush enfolding color, beauty that fills your eyes, texture you can almost touch, mysterious images that challenge and please your senses.

That's the heightened visual excitement you can enjoy with ultraclose-up photography.

This journey starts beyond the minimum focusing distance of your lens, taking you *into* your subject — as far into it as the

close-up accessory you select is capable — from life size (1:1) to ultraclose-up (almost five times life size).

Any lens will get you there, depending upon the close-up accessory you use. Most accessories are made for normal lenses, but I have found satisfying ways to use some with longer lenses.

Equipment. Following are capsulized descriptions of close-up accessories, roughly in order of their cost.

1. *Reverse adapter ring.* This enables you to reverse the normal lens on your camera. Your subject will be about three-quarters life size. It costs about $5 to $8.

2. *Screw-in close-up lenses.* These look like ordinary filters but have magnification power of almost half life size when used in combination. They generally come in sets of three. You can use them individually (effective for copying larger subjects such as art or photos), or in combination. Remember to put the largest number lens on first. Prices range from about twenty-five dollars for a 55mm set to eighty dollars for 77mm.

3. *Extension tubes.* These usually come in sets that can be used individually or in combination. They magnify up to one-and-three-quarters life size. Prices start at fifteen to twenty-five dollars.

4. *Automatic macro converter.* This fits between the camera body and a normal lens. It creates life size images with a normal lens. It can also be used with longer lenses. The cost is around $100.

5. *Automatic bellows.* This accessory fits between the camera and the lens. It magnifies up to three to four-and-one-half times life size. Prices range from three hundred to four hundred dollars, although less expensive ones can be found.

6. *Micro focus adjuster.* This is an accessory that mounts on your tripod. By turning knobs your camera moves in and out and side to side. It is not necessary but makes precise movement easier.

The realm of close-up and macro photography (magnification larger than life-size) packs plenty of visual impact. Through it we see wonders that escape the unassisted eye — like dew on an insect's wing.
Photo by R. Hamilton Smith

Many of these accessories can be used in combination. I enjoy close-up lenses screwed on my zoom lens for creating flower abstractions with diffused edges. I mount the zoom on a tripod and use a micro focus adjuster. As I move in and out and sideways it is like a motion picture — different planes moving in and out of focus, colors changing, the subject becoming more distinct and fading. *That's a fantasy world I can get into!*

There are requirements other than equipment. *You must concentrate and you need patience.* Close-up work is not for snapshooters. It is for artists. Whether you are photographing flowers, coins, stamps, leaves, or insects, you must withhold gratification until you have expended a lot of time and energy in 1) locating (and sometimes capturing) your subject, and 2) setting up.

But it is worth it!

Lighting. Lighting is important for every phase of photography, but for close-ups it is super critical. There is very little room for error in lighting setup and exposure.

Directional light from the side enhances texture, which is a prime element of close-up photography.

You will be greatly concerned with depth of field. Remember, one inch could be the limit of your range of focus. It could be as little as one-quarter inch! If you focus on a flower petal and want one behind it to be sharp, you may have to stop down to f16 or f22.

The intensity of light sets the stage for your creativity and, if you haven't suspected by now, you are going to need a tripod.

Perhaps on a sunny day in the field you may be able to hand-hold your camera for medium close-ups. But don't bet a frame of film that they will be truly sharp.

Steadiness can be so critical at certain times that you may want to shoot at the mirror-up position.

I have had good success working on the shady side of my home, although this is not ideal. For one thing, the light is not directional

The closer you get, the more fantasy you can create. Screw-on close-up lenses on a macro zoom reach to the essence of a flower in this picture, producing a halo of encompassing light.
Photo by Bert Eifer

and light-colored objects pick up a slightly blue cast. This is easily correctable.

You can use any type of light: quartz, household lamps, tensor lamps, ring light, and flash. For black-and-white you can even use fluorescent, but it is less directional than desirable.

Many photographers prefer flash, especially in the field. It has many merits and some disadvantages too.

On the plus side, you can take it anywhere. It is balanced for daytime film and directional. You can place it in any position in relationship to your subject (providing you have the right bracket or other support for it). No need to worry about what a breeze might do to your support or the movement of a galloping beetle.

On the minus side, unless you have a modeling light you cannot be sure exactly what your picture will look like. But the biggest negative is the difficulty of calculating exposure (*see below*).

Reflectors. Reflectors are important in close-up work, especially when using color film. Your eye may see detail in shadows, but the film will not. And remember, it is detail that characterizes your subject and adds the excitement of new discovery! With directional lighting that produces shadows, *filling those shadows is a primary consideration.*

A chunk of white matte board a few inches square will give you all the fill light you need. It's also a good idea to have a mirror about the same size that can be used as a small spotlight.

Reflectors can be supported by leaning them against anything that is handy. A little modeling clay will enable you to stick them in awkward places.

Film Selection. Most professionals prefer transparency film unless they are specifically going for prints. Here are other film considerations. For black-and-white film, use what you are comfortable with. Keep in mind the following when selecting film:

Subject matter for close-ups need not be exotic to be effective. On the contrary, often the most commonplace yield incredibly exciting images as in this photo of wax on glass. That's part of the charm and the challenge of close-up photography — finding worthwhile images where none seemingly exist.
Photo by R. Hamilton Smith

1. *Match your color film to your light source,* or you will have to use a color-balancing filter (which will cost you valuable stops).

2. *Film speed* is important. The magnification you are seeking, and the deep DOF you often desire, substantially reduce the intensity of light reaching your film. So a fairly fast film is desirable. But, like everything else in photography, there are contrary factors at work, in this case more grain than slower films.

3. *Slow shutter speeds* are the rule in close-up work. This can result in another problem: reciprocity failure. After a certain point you have to increase your exposure time. Half-minute exposures of color film and one-minute exposures of black-and-white film require an additional stop above your calculated exposure. At these excessively slow shutter speeds color film will often suffer a color shift and you have to use correction filters, causing additional light loss.

4. *Grain* is variable. The faster the film, the larger the grain. The larger the grain, the less desirable is the film if your end product is to be an enlargement.

The complete *Manual of Close-Up Photography* by Lester Lefkowitz contains charts for filter selection for color-correction filters, as well as filters to balance film to different light sources.

Exposure. Metering for close-up work is very touchy.

Be sure you take your camera meter reading *when you are all set to shoot,* because anything you have in front of your lens will affect the reading — including UV filters.

Only in rare instances will the sky or backgrounds affect your reading, because your image will probably fill your frame.

But if your subject has contrasting colors or strong shadow areas, use the old reliable Gray Card.

Sometimes your light level will be so low (especially if you are using a combination of close-up accessories), that you may not get a meter reading. A way to counter that is to temporarily change the

ISO setting on your camera. Then open your aperture an equivalent number of stops.

Example: You are using ISO 64 film and cannot get a reading. Change your setting to 400. Suppose now you get a reading of f11 at 1/250 sec. There is a 2½ stop difference between 64 and 400 films so you could open to f4/5.6 at 1/250, or to maintain good DOF you would go to f8/11 at 1/60 sec.

For flash, a flash meter is of course the best way to arrive at the correct exposure. In the absence of this type of meter you have to do some mathematical calculations based on your flash's BPS output and distance to subject. Every time you choose the flash-to-subject distance you must recalculate. (However, if you keep good records you will only have to calculate once.)

Keep in mind that a few inches — flash-to-subject distance — could mean a different f/stop!

Bracket, bracket, bracket. There is so much energy expended in setting up, don't blow it by inaccurate exposure. But bracketing will only profit you in the long run if *you record all your shots and learn from them.*

Special Situations. Close-up photography is full of special situations. For instance, copying stamps and other small objects requires a lens that will give you a flat field. The first time I photographed stamps I could not understand why the edges were out of focus. Standard lenses were not made for close copying. There are special lenses that you can purchase if you want to photograph things such as stamps with demanding results.

Coins pose another lighting challenge. They must have directional light from the side at a low angle to make detail stand out. They also need overall illumination.

I have found a successful technique of making a loop of frosted acetate and placing it around the coin. Buy acetate at an art store and cut a strip about six inches long and about one inch wide, and

This is a variation of "tenting." It works for any small object where you want detail that results from even illumination and cross lighting.

make a loop out of it. Place it around the coin like a fence.

This is a variation of a technique known as *tenting* that is a specialty of experienced photographers.

A technique for jewelry close-ups is the use of backlighting reflected onto white cards placed between the camera and the subject.

Individuals with collections of stamps, coins, sculptures (small or miniature), art, scientific specimens, and jewelry require professional quality reproductions for insurance and buy/sell situations.

Perfect this aspect of close-up photography and you have a marketable skill!

Test and Record. More than any other aspect of photography, perfection in close-ups requires experimentation. *Precision* and *repeatability* are the key words. The more attention you pay to details and keep records, the greater the chance you will make your mark in close-up photography, and *gain creative satisfaction.*

So try this and try that and record what you have done in a special notebook. Soon you will see what works and why, and you will simplify your procedures.

Then it will be all play and no work!

Section **6**
Get Started

Without well-conceived guidelines, you rely
on wishes and hopes to rule your destiny. By
waiting for opportunity to knock, you place
yourself in a passive role: You take what
life has to dish out and therefore end up
settling for whatever crumbs happen to fall
your way.

Dr. William J. Knaus, *Do It Now (How to Stop Procrastinating)*

Successful people overcome wishful thinking with opportunity-creating *positive action.* They do not wait for the crumbs, they go for the whole loaf.

Set Goals. It all begins with a plan based around goals. *Set a goal to be a better photographer and you are on your way!*

When you do not set goals you drift, reacting to life instead of *shaping your own destiny.*

Drifters float. Goal-oriented people reach their destination. They know there is no such thing as random, accidental success short of kicking over a rock and finding buried treasure. Yet, and mark this, *almost everyone else operates on wishful thinking.* They are failure bound.

Success in photography begins to happen when you set a major goal. I say *begins* to happen. A goal is the essential blueprint, diagram, strip map. It is the *starting point of every venture.*

A goal fails without execution, follow-through. But without a goal, execution becomes helter-skelter. How many photographers do you know who work hard but never seem to get anywhere? No goal — no destination!

Internalize Rewards. *Fix firmly in your mind what your rewards are for reaching your goal.* Psychologists will tell you this is vitally important for sustaining you through the effort it takes to reach your goal.

What reward awaits you down the road? Is it smashing color close-ups of flowers? A series of impactful sport shots? Deeply revealing character studies?

Find samples of what you want to achieve. Be very selective. *Then post those pictures* in your bedroom, alongside your desk, in your workroom, or on your mirror.

Do you have material gain in mind? Like earning X dollars per month to pull you through tough times? Or is a new camera system your reward? A boat or van? A trip for special shots?

Post pictures of these rewards so you will see them when you get up in the morning and so they will be the last thing you see at night.

Don't charge this whole idea off as a whim of Bert Eifer's. It's a time-proven, psychologically sound way to proceed!

Your goal may be the skill to do unique portraits. *Your reward* is epitomized by pictures that illustrate that goal.

Do the One-Step. Having set your goal and illustrated the reward, you must break your goal down into subgoals. The idea is to *take one small step at a time toward your goal.* As you succeed with each small step your confidence and sense of pride will grow.

Let's say you decide to become an expert in close-up photography. Here are possible small steps you should do *one at a time:*

1. Select your subject, e.g., flowers, insects, coins, stamps, jewelry.

2. Set aside a place to work — kitchen table, desk, patio table — and choose a fabric or backdrop to set off your subject.

3. Set up your lighting, including reflectors.

4. Decide on the correct lens or close-up accessory.

5. Make your film selection.

6. Obtain subjects for photography.

7. Begin shooting, recording every shot.

8. Analyze your slides or proof sheet to determine where you need further experimentation, maybe DOF or different lighting patterns.

9. Set up a project for improving these areas.

If your goal is income from your specialty, your steps might include listing your markets, preparing a portfolio, and establishing prices.

Action. Put your one-step goals in logical order. Start with number one and put the date on it. *Then set a realistic deadline for accomplishing it.* No more than thirty days. Post this goal alongside the picture of your reward.

After completing the first one-step goal, post your second goal with its deadline. And so on until that memorable day when you have that singularly satisfying *feeling of success that comes from reaching a goal and realizing your reward!*

Once you know how, you can go on to another major goal and its reward. And then another.

Evaluate Your Progress. If you have not completed a step within your deadline, *you are at a critical go/no-go crossroads.*

Consider these questions carefully:

1. Do you have a good reason for not completing the step? Honestly?

2. Should you extend your deadline ten more days?
3. Was the goal too ambitious?
4. Should you go back to a prior goal and redo it?
5. Should you set a different major goal?
6. Or should you put your camera in mothballs?

You see, each goal set is a commitment made. *A contract with yourself.* Oddly enough, we are more prone to violate a contract with ourselves than one with others. What does that have to say about our feeling of self-worth?

The point is: *commit or quit.* (*See Fulfill Your Expectations.*)

Anti-Inertia Program. We all know that it takes a lot of energy to move a body at rest (do we ever!). Maybe you've had the experience of pushing a stalled car and know what it takes to get it moving. After it begins to roll (having overcome inertia), the pushing is easier.

The same problem exists when we take on a task, whether it is simple like sweeping the floor or more complex like setting up a system for filing negs.

Here is Eifer's tried and tested *Step-by-Step Anti-Inertia Program.*

1. Visualize the task in your mind and *state the first tiny step,* like opening the broom closet door, or finding space for sorting negatives.
2. *Elevate your bottom* from the chair, bed, sofa, stool, etc., to a standing position.
3. *Pivot in the direction* of the task (broom closet, sorting space).
4. *Take one step in that direction.*
5. You have just overcome inertia!
6. *Keep rolling* so you don't have to push that stalled car again from a standing start.

Summary. It cannot be stated too often or too strongly: *The world belongs to the doers.* Doers are planners. Planners start with goals. All the rest are dreamers. Wishful thinkers.

In his novel *The Pearl,* John Steinbeck said a great deal about planning. "A plan is a real thing, and things projected are experienced. A plan once made and visualized becomes a reality along with other realities — never to be destroyed but easily to be attacked."

Doers, planners shape their own destinies. The rest are "victims of circumstances." Losers.

Become a winner in photography and everything else in life by taking control of your life.

You start by setting goals!

Ten Steps to Creating Remarkably Better Pictures

PRESHOOT

1. Select the photo opportunity that you are most interested in. They are everywhere: in your backyard, at the local playground, in your kitchen, at the rodeo, the national parks, your town or city, as well as in exotic places. *Everywhere and anywhere you open your eyes, your heart, your mind* to the beauty of nature, to man's handiwork, and to the human condition that surrounds you.

2. Make a list of everything you will need for the conditions and opportunities you will encounter: equipment, supplies, props, tools, makeup, etc.

Check out your equipment, your batteries, meters, film and flash supply, etc. Take back-up equipment.

THE SHOOT

3. Your *mental-set* is most important. You must approach your photo opportunity with fresh eyes, a detached attitude, as if you just arrived from a distant planet. A tree is not a tree but a living sculpture. It should be photographed as such. A bicycle gear cluster is a series of interrelated forms, not something you dismiss with a glance as a bicycle gear.

The right mental set means you will take the time to discover, and to look *into* your subject, to caress it with your eyes. An attitude of relaxed expectation, with no preconceptions.

4. *Select and study your subject carefully.* Photography is a selective art. Select what appeals to you out of the unlimited possibilities that confront you.

Zero in on your target. Look for, and at, shape, form, design, texture, color.

Be especially conscious of light. The quantity, quality, and color of the light will "paint" your subject and influence your mood. Move around to make the light work better for you. In the studio, move your lights around for different effects.

Squint at your subject. Squinting eliminates details, and background and brings out shape and contrast in tones and colors.

Keep refining your vision of the subject or scene before you, always opening your mind to what your heart tells you.

5. *What does the scene say to you?* How does it *feel* to you? What idea, emotion, mood, information do you want to convey?

6. *Put your feelings* (or point of view) *into words.* This may be the single most important step toward producing photographs with emotional content, photographs that *communicate.*

7. *Previsualize the completed photo.* This step is absolutely vital and one that pros would never bypass on important shots.

Do you want the final picture to appear exactly as you see it? Darker? More pastel? Crisp or diffused? Do you see details in the

shadows in your finished print? Or maybe a silhouette? Do you want the foreground sharp or out of focus? Maybe the ideal print can be solarized, or even sandwiched.

If you don't see it in your mind before you shoot, you won't see it in the final print or slide!

8. State with your camera what you see in your mind. The first seven steps are the art of photography. Now the easier part: the craft of photography. Technique. Which of your camera's fifteen creative options should you bring into play?

Once you have the picture in your mind, it is easy to exercise your command of your camera's creative controls, to adjust your controls to what you envision. The controls are literally at your fingertips.

POST SHOOT

9. Consider negative or print manipulation. You can of course modify the contrast of your black-and-white negs, especially if you understand the Zone System.

There are a myriad of things you can do (or have done) to the print, either black and white or color, *to bring to life* the vision you had in your mind when you clicked the shutter.

Finishing: trimming, mounting, matting, framing. The finishing touch can enhance your image, or ruin it.

10. Perform a self-critique. You have now come full circle. This is the place where sober learning takes place. Did you accomplish your mission? Have you captured the feeling you had in mind? Do you have the thrill of seeing your previsualization realized?

If not, why not?

Perhaps you cannot see your own creation objectively. Is there someone whose opinion you trust?

Success, near success, or failure? Profit from the experience. *This is your guide to future success.*

Self-Critique

Here is a guide for evaluating your own photos. It is structured so that, perhaps for the first time, you can look at your work *objectively, dispassionately.*

A critique of your work by an expert is the surest way to get an objective view of your strengths and weaknesses. The next best thing is self-critique.

Try to look at your pictures as if you were someone else. If you can project your thinking in this manner, you will be well on your way to learning how to improve your work!

Evaluate a few of your best photos with this guide and you should find a pattern developing. Your shortcomings will become evident. But you'll feel no pain because, remember, *this is not your work you are critiquing but that of a "stranger"!*

All of the following questions can be answered objectively. The subjective has been eliminated, *enabling you to make sound, dispassionate judgments* about these elements of your pictures:

1. *The idea.* Does the photo say something? Is it important? Expressed in a new way? Profound? Does it go *to the heart of the subject,* revealing something beyond the obvious, something unique or novel — especially novel?

The idea should be simply and clearly stated. Any element that takes away from or does not support the idea hurts the picture.

2. *Fulfillment of intent.* How well did the photographer accomplish what he set out to do? Often the intent is obvious, and the results more obvious. One characteristic of good photographers is their ability to repeatedly get on film exactly what they intended.

3. *Emotional content.* How does the picture make you feel? Is there an appeal to your senses that produces an emotional bond?

4. *Illumination.* Does the lighting serve the intent? Does it give

dimension to the subject, substance, detail? Does it enhance the mood?

5. *Subject/background contrast.* Is there sufficient contrast between the subject and background to clearly delineate the subject? Or does the clarity of the photo suffer from lack of contrast?

6. *Illusion of depth.* Does the photo have the third dimension of depth to confirm to the viewer that the photo represents the real world?

7. *Center of interest.* Is there one point of the photo to which the eye immediately gravitates? Is that point at the Golden Mean? More important: Is that the point the photographer *wanted* to attract the viewer's eye?

8. *Pattern.* Is there a repetition of shapes or tones or line or texture that sets up a rhythm that is pleasurable to the eye?

9. *Perspective.* Did you make an effort to vary from the normal viewpoint, adding freshness and impact?

10. *Format.* Does the format suit the shape of the object or scene? Does the format strengthen the image? Would cropping bring it out more?

11. *Color considerations.* Are the colors working together to help the picture? Squint when looking at a color picture and ask yourself: *Would it be effective as a black and white?* Does it have the qualities of good composition that would hold up without the impact of color? If it does, then the natural attributes of color will make it a real winner!

12. *Technical excellence.* Is the picture of professional quality from start to finish (including such fundamentals as sharp focus), to final print.

13. *Success/failure.* What is your final, hard-nosed decision? Success or failure? Nothing in between counts.

Take a simple example: a photo of your child or grandchild. It is charged with the emotion of love, so much that you do not see (or care) that the focus is not sharp.

But when you look at the picture with a different mind set, *with the desire to be objective and honest,* you have to conclude that the picture fails in technical excellence. It is out of focus!

Summarize what is right, what is wrong with the pictures you have evaluated. List areas that need improvement — and go for it. List your areas of strength and play off them.

Accent your positive; eliminate your negatives!

Now is an excellent time to go back and review your Creativity Strength and Weakness Checklist.

Analyze Your Style

Do you have a unique photographic style?

Line up as many of your best photos as you can find. Look at all aspects of your work. Is there a common denominator?

1. Is strong composition your forte? Abstract design, precise detail, bold contrasts rhythm, or pattern, texture?

2. Do you choose strong color renditions or prefer more muted tones? Do your colors tend to contrast or blend?

3. Do you specialize in close-ups? Landscapes? People? Do your landscapes incorporate birds, waterfalls, river bends? Or human artifacts such as old mills, churches, bridges? Or do you zoom in on windows, reflections, insect damage, cracks in pavement and dried earth? Does your work portray a theme such as love, fear, devotion? Do your subjects stand alone or in groups? Or playing off against another. Do your wildlife shots focus on action, mating, survival, or colonies interacting?

4. Is there something uniquely different about some of your work that, if integrated into most of your pictures, could become

your style? Determine your market?

Answers to these questions will give you a clue to your own style, as well as your subject preference. Your subjects and themes will help you evolve your style and techniques.

Study the work of photographers whose style you admire in areas in which you are interested. Don't be afraid to imitate them. Chances are they began in the same way. Artists learn by copying the masters. You can too.

We are all influenced by what has gone before. Eliot Porter stated it this way: "Nothing can be done in the realm of art without influence from somebody. Many young photographers are fearful of being accused of imitating, copying, or following in the footsteps of another photographer. But no one can actually copy work. Each person sees and perceives in a unique way. And yet, nobody is free of influence of his predecessor and contemporaries."

Concentrate on your most unique areas by making lots of pictures. Critique and shoot. Shoot and critique until you *add a dimension of your own, your own style.*

Beware: *Do not try to formulate a style until you have mastered the basics.* They cannot be bypassed with any lasting success. Everyone must pay his dues.

Joseph Ruskin, Director of Photography for McGraw-Hill, put it this way. "Technical expertise is a skill which has to be acquired. Once you learn the techniques, once you have mastered the book, then you go to another stage where you depart from the rules — and that is where you develop your style, which makes you unique. That's what style is about — departing from the rules. But you can't depart from the rules until you have mastered them."

Create Your Own Personal Style

Every artist and craftsperson aspires to a style that is singularly his. A trademark. A personal stamp. An approach that is unique, individualized, personalized, *like no other.* Style is one's personal expression of what he sees and feels. It is self-expression in a world of sameness and conformity.

You know this is true. You can name the creator of a great photograph or painting or sculpture or sonata or book without seeing the creator's name. This is the test of fame in all areas of artistic endeavor.

Such recognition comes to only a few, bringing fame and sometimes wealth. The fact that only a few attain this pinnacle of success does not, and should not, deter you from reaching for the stars.

Even if you fall short, you will never come up with a handful of mud because, in trying, *you will have progressed a lot further than normal.* You will have touched all bases. You will know much of what the masters know. And *you will be photographing at your maximum potential.* How rare an accomplishment!

Attaining a style of your own is an ongoing process that comes from mastering the basics of photography, especially the art of seeing photographically. It is a mistake to expect results too soon, or by accident. You cannot break the rules — which by and large are part of the definition of style — until you know them, until they become part of you.

Select an Ideal. There are many stylists in every area of photography. Select the role model in your chosen area who best represents the style you would like to integrate into your work.

Learn all about the photographer. Understand his viewpoint, his thought processes. *Collect his work and study it.*

You will find that his camera (no matter how expensive) did not come equipped with a built-in photographic style. He worked long and hard and suffered much rejection. One thing for certain, it all started with *mastering the basics*. He knows them upside down and backward.

If you think you can sneak into success without comparable knowledge, you will come up short like everyone else who tries shortcuts.

What is it about the photographer's work that most appeals to you? *What are the factors that make his work different or unique:* ideas, subject, lighting, composition, use of color, selection of lenses, perspective, sharpness or diffusion, background, props, film, print manipulation?

Pin them down. It's critical that you do this because that is your starting point.

Start by Imitating. What — imitate, copy? Yes. All artists begin by absorbing from others. Most photo instructors will tell you that their students incorporate some of their ideas, their approaches, their style. But instructors want students to go beyond their skills. A Japanese expression says it like this: "A teacher's reward is to be surpassed by his students."

Master painters often learned as apprentices. Their early work closely approached that of their teachers and sometimes no one could tell whose was the original. Today you still find advanced art students at their easels in the great museums of the world copying the masters stroke for stroke as part of their learning of technique and style.

And when finally they are able to imitate successfully, only then do they *begin to evolve a style of their own.*

I can tell you this with absolute certainty: *Right now you are*

imitating someone, consciously or unconsciously. So you might as well do it in an orderly, studied way.

Yes, imitate until you master the skills that enable you to advance to a style that expresses who you are.

Add a Piece of Yourself. If you have the true makings of an artist, you will *add something of yourself,* a personification of all that you are and can be. Your photographs will say "This is me."

At that point in time you will be recognized as an artist in your own right. Your work will be in demand. Your price can be virtually whatever you ask.

And most important, even if you do not reach that optimum state (and few do), you will have pushed yourself to your fullest potential. *You will become the very best photographer that you can be!*

That is reward enough — life's richest reward.

7 Fulfill Your Great Expectations

What you are has a lot to do with what your parents expected of you. *What you can be has everything to do with what you expect of yourself!*

The magic word is *expect.*

When you say "I expect," it's like magic. More about that later.

In photography, as in all of life's endeavors, *many more fail than succeed.* People of equal intelligence and aptitude may attend the same classes, hear the same lectures, read the same magazines and books, and probably have comparable equipment. Yet the degree of success, the degree to which they are able to use these learning experiences varies widely.

The first step to failure is the inability to grasp that *what is being presented is directly applicable to you.* Many fail to make that connection. Many experience a learning situation as spectators rather than as participants. *Why?*

Case in point: Over the years, I have recommended through *APIdea Newsletter* a way to perfect portraiture techniques without the expense of a model: Buy a mannequin head and wig and practice to your heart's content.

Many enterprising photographers think this is a great idea, but only a few have actually put it into practice.

Will you? Will you make the connection that this information applies directly to *you,* if you want to remarkably improve your portraiture as example?

Fear
of Failure

Fear of failure, even private failure, stultifies people. By private failure, I mean situations where you have no one else to please but yourself.

In your heart of hearts do you reject an idea because you feel you might fail to achieve perfection?

That is the whole point of experimenting and practicing.

Failure: Step to Success. You learn more from your mistakes than from your successes — unless you believe Leonardo da Vinci decided one day to take up painting and proceeded to paint the Mona Lisa the same day.

Art is a growth process, an evolving process. Growth depends on learning from trial and error — from failures.

So, in truth, failure is an important and necessary part of learning. We fail over and over again before we succeed.

We succeed *because* we have failed.

If you do not risk the chance of failure, you do not have the chance of success! This applies to photography as well as every other facet of your life.

Attitude vs.
Aptitude

A. D. Coleman, one of the premier critics of photography, has stated he is not too concerned about whether a photographer has talent or not. To him, *patience and courage are more important.*

In other words, *attitude is more important than aptitude.* If you look into any field of accomplishment you will find that raw talent alone is never at the top of the field. Most winners reach their goals through hard work, study, practice, and dedication.

Add these factors to even a *little* talent and you have the formula for success.

Human Potential. I am in this business because *I believe in human potential.* I firmly believe (and it has proven to be true) that *anyone* — everyone — *can perform at a far higher level.* But it takes effort.

The road to vast improvement can be fast and smooth *if you just get your momentum going.*

"I Will." *What you expect of yourself is what you will be.* What you expect to accomplish is what you will accomplish.

When I am jogging and tired, if I say to myself, *"Maybe* I can make another lap," I will not.

If I say, *"I am going to* make another lap," I will.

If *you expect* to elevate your level of photographic achievement (or any other achievement), *you will.*

This is not a Bert Eifer idea but one that can be verified by basic human psychology... or by anyone who has succeeded in any field.

Fulfilling Your Expectations

1. *Arrange your priorities* in the order of greatest importance to you. Eliminate any that you do not feel strongly about.

"I *expect* to shoot the best scenics of my life on my next vacation."

"I *expect* to develop a portrait style of my own."

"I *expect* to excel in ultraclose-up photography."

"I *expect* to pay for a Hasselblad or a boat through spare-time freelancing."

"I *expect* to ."

2. *Write each expectation on a separate sheet of paper.*
3. *Find photos that represent these goals.*
4. *Mount each of your expectations and photos on a separate sheet of paper and tape them to a wall.* Date each one and write down your first step — *first step only.* This might be "write a marketing plan," or "buy a set of close-up filters," or "research the subject," or "start a price list," or "make preliminary selections for a portfolio."
5. When you have completed your first step, *write down your second step* and date it.
6. *If, after thirty days, you have not completed the first step,* remove that expectation and discard it. This serves to narrow your priorities and put them in proper order.

Go to the next step.

If you narrow them down to zero, that has merit too because *you might as well not keep kidding yourself.* You may get your kicks

from staring at a blank wall, *a wall of no expectations.* You will have plenty of company.

7. *Continue the process* of writing down each step. You will soon find your wall covered with completed photographs that *fulfill your great expectations!*

From there on THERE IS NO STOPPING YOU. You will have experienced the sweet smell of success, and there is nowhere to go but UP.

The world belongs to those who strive to reach the maximum of their ability. . . their potential.

You see, *reaching your potential,* being all that you can be, in photography or whatever you choose, *is its own success and one of the greatest keys to happiness.*

Recommended Books

There are many fine books on every subject in photography. Of those that have come to my attention, these are ones I recommend. In addition to this list I urge you to read books written by, or about outstanding photographers such as Steichen, Avedon, Strand, Picker, Caponigio, Haas, Adams, Callahan, Cartier-Bresson, W. Eugene Smith, Minor White, Julia Margaret Cameron, Weston, Dorthea Lange, Arnold Newman, George Tice, Freeman Patterson, to mention only a few.

Close-Up Photography

Adventures in Closeup Photography. *Ericksenn and Sincebaugh, Amphoto Books, New York.*

The Manual of Close-Up Photography. *Lester Lefkowitz. Amphoto Books, New York.*

Color Photography

The Art of Color Photography. *John Hedgecoe. Simon and Schuster, New York.*

The Book of Color Photography. *Bailey and Holloway. Alfred A. Knopf, New York.*

Color Design in Photography. *Harold Mante. Van Nostrand Reinhold, Inc., New York.*

Composition in Art

Concept and Composition. *Fritz Henning. North Light Publishers, an imprint of Writer's Digest Books, Cincinnati, Ohio.*

Composition in Photography

Photographic Composition. *Clements and Rosenfield. Van Nostrand Reinhold, Inc., New York.*

Commercial Photography

Professional Industrial Photography. *Gerald E. Martin. Amphoto Books, New York.*

Professional Photographic Illustration Techniques. *Eastman Kodak, Rochester, New York.*

Darkroom

Darkroom: Techniques of 13 Masters. *Lustrum Press, Distributed by G. Light Impressions Corp., Rochester, New York.*

Creative Darkroom Techniques. *Eastman Kodak. Rochester, New York.*

The Essential Darkroom Book. *Grill and Scanlon. Amphoto Books, New York.*

The Darkroom Handbook. *Michael Langford. Albert A. Knopf, New York.*

Lighting

Photographic Lighting: Learning to See. *Ralph Hattersley. Prentice-Hall, Inc., Englewood Cliffs, New Jersey.*

Techniques of Photographic Lighting. *Norman Kerr. Amphoto Books, New York.*

Photography, General

Exploring Photography. *Bryn Campbell. Hudson Hills Press, New York.*

The Photographer's Eye. *John Szarkowski. The Museum of Modern Art, New York. Distributed by New York Graphic Society, Boston.*

The Photographer's Handbook. *John Hedgecoe. Alfred A. Knopf, New York.*

Vision, Composition and Photography. *Ernst A. Weber. Walter de Gruyter. Distributed by Van Nostrand Reinhold, Inc. New York.*

World Photography: 25 Contemporary Masters Write About Their Work, Techniques and Equipment. *Edited by Bryn Campbell. Ziff-Davis Books, New York.*

Portraits, Informal

How to Create Great Informal Portraits. *Bill Thompson. Amphoto Books, New York.*

How Do You Photograph People? *Leigh Wiener. A Studio Book. The Viking Press, New York.*

Portraiture

The Complete Book of Photographing People. *Michael Busselle. Simon and Schuster, New York.*

50 Portrait Lighting Techniques. *John Hart. Amphoto Books, New York.*

Techniques of Portrait Photography. *Bill Hurter, Prentice-Hall.*

Professional Portrait Techniques. *Eastman Kodak Co., Rochester, New York.*

Seeing

Photography & The Art of Seeing. *Freeman Patterson. Van Nostrand Reinhold, Inc., New York.*

The Zen of Seeing: Seeing/Drawing. *Frederick Franck. Vintage Books, Division of Random House, New York.*

Selling Your Photos

Photographer's Market (Annual). *Where to Sell Your Photographs. Writer's Digest Books, Cincinnati, Ohio.*

Sell and Resell Your Photos: How to Sell Your Pictures to a World of Markets as Close as Your Mail Box. *Rohn Engh. Writer's Digest Books, Cincinnati, Ohio.*

Special Effects

Focus on Special Effects. *Don and Marie Carroll. Amphoto Books, New York.*

Sports Photography

Filming Sports. *Eastman Kodak, Rochester, New York.*

Understanding Art

Learning to Look: A Handbook of the Visual Arts. *Joshua C. Taylor. Smithsonian Institution Press, Washington, D.C.*

To See Is To Think: Looking at American Art. *Joshua C. Taylor. Smithsonian Institution Press, Washington, D.C.*

What Is Art? *John Canaday. Alfred A. Knopf, New York.*

Wildlife and Nature

The Complete Book of Wildlife and Nature Photography. *Michael Freeman. Simon and Schuster, New York.*

Photography of Natural Things. *Freeman Patterson. Van Nostrand Reinhold, Inc., New York.*

Zone System

Beyond the Zone System. *Phil Davis. Curtis & London, Inc., Distributed by Van Nostrand Reinhold, Inc., New York.*

The Zone System for 35MM Photographers. *Carson Graves. Curtis & London, Inc., Distributed by Van Nostrand Reinhold, Inc., New York.*

Books by Arnold Newman

Bravo Stravinsky

One Mind's Eye: The Portraits and Other Photography of Arnold Newman.

Faces USA

The Great British

Artists: Portraits from Four Decades

Books by Freeman Patterson

Photography & The Art of Seeing

Photography of Natural Things

Photography for the Joy of It. *Van Nostrand Reinhold, Inc., New York.*

Books By George Tice

Urban Romantic

Fields of Peace (with Millen Brand)

Goodbye, River, Goodbye, (with George Mendoza)

Paterson

Seacoast Maine (with Martin Dibner)

George A. Tice/Photographs/1953-1973

Urban Landscapes

Artie van Blarcum. *David R. Godine, Inc., Boston.*

Index

Other Books Of Interest

How to Create Super Slide Shows, by E. Burt Close $10.95, paper
How You Can Make $25,000 a Year with Your Camera, by Larry Cribb $9.95, paper
Photographer's Market, $14.95
Sell & Re-Sell Your Photos, by Rohn Engh $14.95
Starting—And Succeeding In—Your Own Photography Business, by Jeanne Thwaites $18.95
Wildlife & Nature Photographer's Field Guide, by Michael Freeman, $14.95

To order directly from the publisher, include $1.50 postage and handling for 1 book and 50¢ for each additional book. Allow 30 days for delivery.
Writer's Digest Books, Dept. B, 9933 Alliance Rd., Cincinnati OH 45242
Prices subject to change without notice.

If you'd like more information on Associated Photographers International, write to:
 Bert Eifer
 % API
 21822 Sherman Way
 Canoga Park, CA 91303